SHOCK TREATMENT

SHOCK TREATMENT

KAREN FINLEY

with illustrations by the author

City Lights | San Francisco

Book design by Rex Ray
Cover design by Herb Thornby
Cover drawing by Karen Finley

Parts of this book have appeared in *The Drama Review, Blatant Artifice, ArtForwn, The Whole Earth Review, Paper,* and *City Lights Review.*

Library of Congress Cataloging-in-Publication Data
Finley, Karen.
 [Prose works. Selections]
 Shock treatment / Karen Finley. — Expanded 25th anniversary edition.
 pages ; cm
 ISBN 978-0-87286-691-1 (softcover)
 I. Title.
 PS3556.I488A6 2015
 818'.54—dc23
 2015023038

City Lights books are published at the City Lights Bookstore
261 Columbus Avenue, San Francisco, CA 94133
www.citylights.com

NOTE FROM THE EDITOR

When Karen Finley and I were putting together a manu-
script in the late 1980s, we had no idea that these texts
would become a lightning rod in the Culture Wars soon to
be waged by right-wing conservatives. But as *Shock Treat-
ment* came off press in 1990, Karen was suddenly cata-
pulted into the center of a controversy about public arts
funding and what constitutes valid artistic expression. She
went from being an avant-garde performance artist with a
niche following to being written about in *People* magazine
in less than a week. In a pre-Internet era, that was pretty
shocking. It could fuck you up in personal and professional
ways. But Karen faced down the haters with grace and clar-
ity. This wasn't an opportunity, as some people claimed, for
Karen to capitalize on celebrity. It was a struggle against
being defined by how the wing nuts depicted her.

Karen's work addressed audiences under siege—the
AIDS crisis was a calamity of unspeakable dimensions. In
these texts she was able to put into language what it felt
like to live and die in those plague years, when the bru-
tality of deadly disease was surpassed only by the fear-
some culture of cruelty surrounding the most vulnerable
communities.

I was a young editor working by day at City Lights Publishers, a venerable institution known for championing renegade literature ever since the Beat era, and I wanted to contribute to that mission. I was working in the evenings as a clerk in the bookstore downstairs from the publishing offices, and that's where I met Rex Ray, an artist who was attending the San Francisco Art Institute, and who was just beginning to develop a Mac-based practice in graphic design. He was working in the bookstore too, we became fast friends, and he introduced me to Karen.

When I saw her perform the first time I thought, this is how people must have felt when they heard Allen Ginsberg read "Howl" some thirty years before. Karen's performances were transformative for audiences lucky enough to see her in person, and I wanted to bring her work to people who might not make it to the Mudd Club or the Pyramid Club or the DNA Lounge. Her courageous excoriation of misogyny and homophobia translated brilliantly to the page. With the prospect of publishing a book with City Lights, she developed a range of writing gestures, which continue to influence and inspire multiple generations of artists and writers. Rex created the distinctive design for *Shock Treatment*, using Karen's texts and drawings. It was a formative project for all of us—we trusted each other. I learned that publishing books is motivated by many desires, but for me, above all, it is about relationships.

Over the years I have had the privilege to work on other books and projects with Karen. I collaborated with Rex for two decades. He created an aesthetic for many of my publishing projects, which perfectly suited the works. (It turns out that sometimes, you can judge a book by its cover.) When he passed away in February of this year, I called Karen and we talked about our connection to one another and to Rex, which began with publishing this book twenty-five years ago. Hearing her voice on the phone, I

remembered the time when, in finalizing the manuscript for *Shock Treatment*, she called from New York to tell me that she had just finished a new poem for the end of the book. She read "The Black Sheep" to me and I sat stunned by the beauty and raw power of this empathetic poem. This project with Karen would help me to dream a life that is about art and work and friendship.

I don't remember the last time that Karen, Rex, and I were all in the same room together. It's been years. But I do know that we each emerged from this project feeling like we were creating a world together, inviting people in, and hoping this book would resonate over time, and it has.

<div align="right">

Amy Scholder
July 2015

</div>

INTRODUCTION TO THE
25TH ANNIVERSARY EDITION

I am honored to write an introduction to the 25th anniversary edition of *Shock Treatment*, and to share my thoughts on the meaning of this milestone. City Lights has had an instrumental role in my life as an artist, a writer, an activist, and a citizen.

Thinking back to the summer of 1970, the summer before beginning high school, I remember browsing through the poetry section of my local library in Evanston, Illinois in search of meaningful expression. I had been looking at a book on Happenings by Michael Kirby, and since some of the artists mentioned in that book used poetic language I decided to look for books of verse.

I was struck by the title *Golden Sardine.* It seemed to jump off the shelf into my hands. I can still see the ochre cover with Kaufman's portrait. *Golden Sardine* by Bob Kaufman was part of the City Lights Pocket Poets series. I was mesmerized by Kaufman's style of writing, his daring use of language revealing emotion, taking on social issues, using language as resistance. It felt like a magical moment, standing and reading in the stacks. I didn't want to check the book out and read it elsewhere, for fear something would

disrupt the enchantment I was experiencing. In these private moments of reading, poetics guided me to create an interior space for resistance to the outside world. Poetry is not just about sound and nature. Poetry is about speaking up and out. In this act of reading, I had found illumination.

I moved to San Francisco to attend the San Francisco Art Institute in 1977. I lived in North Beach and found work across the street from City Lights as a cocktail waitress at the infamous Condor Club, featuring topless performers starring Carol Doda. Later I moved down the street to El Cid. The owner was taking a writing class and brought me his work to read. In those days North Beach was a crazy combination of burlesque, punk, comedy, poetry, film, and Beat, set within Italian and Chinese neighborhoods. Even though San Francisco was not a 4 am-last-call kind of town, the cafes were open late and it seemed like most people did not work 9-5. It was a city of artists, not of accountants.

City Lights was open well into the evening. Reading was encouraged; loitering was allowed. After work I would venture from the burlesque house to the bookstore and sit with acclaimed writers like Richard Brautigan and Gregory Corso.

As a young feminist writer I found it difficult to find freedom and artistic opportunity within male-defined spaces. While men were finding artistic triumph on the road, those spaces were impossible for most women, whose fears of violence and attacks of all kinds were real.

Kathy Acker was my teacher at the San Francisco Art Institute. She offered a way out of traditionally paternal pedagogical structures, providing me a profound and inspired female mentor. Her approach to language chaos, text appropriation, and collage released nontraditional methods of art-making and narratives of splitting—an intensity that became part of my working vocabulary.

My early performances were written and performed in San Francisco with full awareness of the infamous poetic generation before us. My goal was to participate in a female voicing of this legacy. In "The Constant State of Desire" and "We Keep Our Victims Ready," I displayed my body while voicing hysteria and rage. I showed what it looks like to lose control while being in control.

Breaking taboos came at a cost to me. I was feared, attacked, sexualized—a Medea with venomous spittle. My work was brought to the floors of congress, on the front pages of daily newspapers. I was criticized as a heathen. My performances were often not permitted. In England, where it was illegal for women to speak and show their nude body at the same time, I was forced to leave the country.

At the time of publication of *Shock Treatment* in 1990, the nation was in the midst of the culture wars. Three artists (John Fleck, Holly Hughes, Tim Miller) and I had been selected by the National Endowment of the Arts to receive grants for solo performances but they were then removed because of "indecency." The sexual panic and hysteria that erupted from this government decision sparked further anxieties about otherness, sexual identity, and the performance of gender fluidity. Eventually we brought that case to the Supreme Court of the United States, *Finley vs. National Endowment of the Arts.*

The AIDS epidemic was raging and the US government was in denial. By 1990 almost 200,000 were diagnosed with HIV/AIDS and over 120,000 had died in the US alone. George Bush was in power. Act Up disrupted Wall Street, successfully protesting the high price of AZT, the first government-approved treatment of HIV. By August the first Gulf War began. And another kind of war was underway against artists and nonprofits. Jesse Helms, a senator from North Carolina, who had opposed civil rights in the 1960s, set out an agenda against homosexuality, feminism,

disability rights, access to abortion, and affirmative action. Artists and writers were routinely disparaged. The writings in *Shock Treatment* comprised of some of the performance texts that were under attack at that time.

Certain traditions of poetry and the legacy of the Beats inspired me. I thought of City Lights' own relationship to censorship—the 1955 publication of Allen Ginsberg's *Howl*, which resulted in a historic obscenity trial. I was determined to keep my focus on preserving free speech.

Of course, culture wars continue to this day. The threat of censorship still exists. The complex and terrorizing events around the world—and I'm thinking right now about the recent attacks in Paris—are devastating to all citizens. Where do we go from here?

I reflect on the dedication of Lawrence Ferlinghetti, one of America's foremost poets and also founder of City Lights Books. It was his generosity of spirit and imagination, which made possible the City Lights enterprise. City Lights provides a place for community, and publishing as social activism. This contribution impacts on the most intimate level of the reader and neighborhoods and well beyond the Golden Gate Bridge. Here is a poem I've written in tribute to being part of the City Lights legacy.

Let me tell you about *Shock Treatment*
And take you into her hearth
A grandmother gives too much
By robbing dirt's grave
And spreads that shit in my mouth

Let me tell you about how I wrote it
But rather how you wrote it
How we wrote it together

With full malicious intentional disruption
Disappear imperial purgatory politics

But it was always about more
Leaving shame for healing
I wish my book could have done more
Like save a bullied child before jumping off the bridge
For it is only words not action

A tender tempo uprising before a millennial
The nostalgia for espresso respected
Loneliness equated with Beat
Let me take you to the party as my guest
I need snow to be happy

Once I was hit by a car, a bug, a beetle
Just on the road from City Lights
On old Columbus zig zag
I wasn't hit too bad
Wasn't hit too bad
Wasn't hit too bad
Wasn't hit
Too bad

Listen to my poetry
The words sink in like bad habits
A sweet ooze of discomfort
I can never get enough
Waiting to overdose an octave

Let's look at all that happened
And all we have been through
As if the last generation gives us a lens
Like a crystal ball
To predict an uneven hand and deck

Wars, AIDS, social injustice,
Inequality, marginalized mobility
Racism, policism
Black Lives Matter
Shall we name names?
Trayvon Martin, Eric Garner, Michael Brown
Take to the streets!

Sometimes so afraid of what will happen
What has happened
Please don't hide and whither
Hear the words of thunder
The pitter-patter of tongue
Lips smack
Biting words sting the air

Freedom words language image
Contested
The battlefield of expression
Help us listen
Help us voice
Help us respect
Help us reflect
Help us respect
Help us with the freedom of speech
And to leave room
To be offended
Haunted at the evils of taboo
My darkest hour
Is when you
See no way out except
For violence

Take up the pen
Take up the pencil

And marvel in all
Her lines
Executed

I dedicate this anniversary edition to my daughter, Violet.

Special Thanks
To my editor, Amy Scholder, for her strength and her
generous belief in my book before it was even completed.
Thank you Rex Ray for introducing me to Amy.
To Nancy Peters, for her guidance and wisdom.
To Dona Ann McAdams, photographer.
To David Hershkovits at *Paper*.
To Art Matters and Anne Marie MacDonald for their
support in helping me realize this book.

To my husband,
Michael

CONTENTS

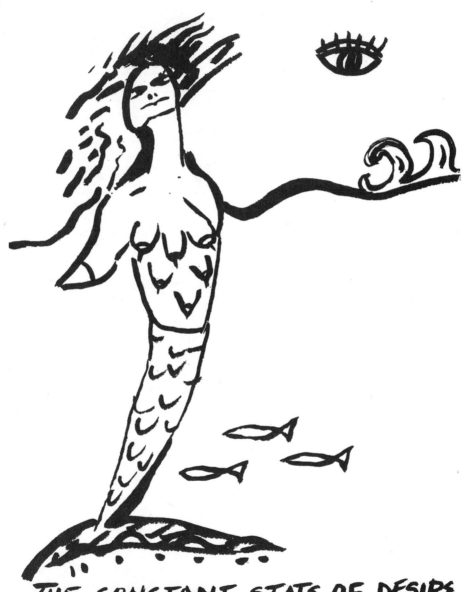

THE CONSTANT STATE OF DESIRE

THE
CONSTANT
STATE
OF
DESIRE

STRANGLING BABY BIRDS

She dreams. She dreams of strangling baby birds. Bluebirds, wrens and robins. And with her thumbs she pushes back on their small feathered necks, pushes back against their beaks till they snap like breaking twigs.

She dreams. She dreams of being locked in a cage and singing loudly and off-key with her loved ones standing behind her, whispering very loudly, "She has an ugly voice, doesn't she? She has an ugly voice." Oh, leave it to the loved ones always to interfere with our dreams.

She dreams. She dreams of falling out of a fifth story window. But she catches her fall by holding onto the window ledge. It's January and the ledge is made of

stone. The ledge is icy, frozen and cold. The stone and the ice cut through her flesh, cut through her fingers, her bones. It doesn't matter, though, for she has ugly fingers. She sees the blood gush out of her limbs the more she holds onto the ledge. She can hear her own death. As she hangs out the window her husband walks below, but her husband hadn't memorized her shadow and she didn't know how to wear perfume. She just wasn't that kind of a girl.

So she cried out for help. Help. HELP. Helllp. HEEELLP! But the wind was in a mean mood and took her cries half way 'round the world to a child's crib so its mother could hear her own child's cries.

This dream was considered very important to the doctors. For in the past she had dreams of tortures, rapes and beatings where no sounds would come out at all. She'd open up her mouth and move her lips but no sounds would come out at all. You know those dreams. You know those dreams.

But she knew that these doctors were wrong. For these were the same doctors who anesthetized her during the birth of her children. These were the same doctors who called her animal as she nursed. These were the same doctors who gave her episiotomies. No more sexual feelings for her during and after childbirth.

But she knew that it really wasn't the doctors' fault. That the real problem was in the way she projected her femininity. And if she wasn't passive, well, she just didn't feel desirable. And if she wasn't desirable she just didn't feel female. And if she wasn't female, well, the whole world would cave in.

3

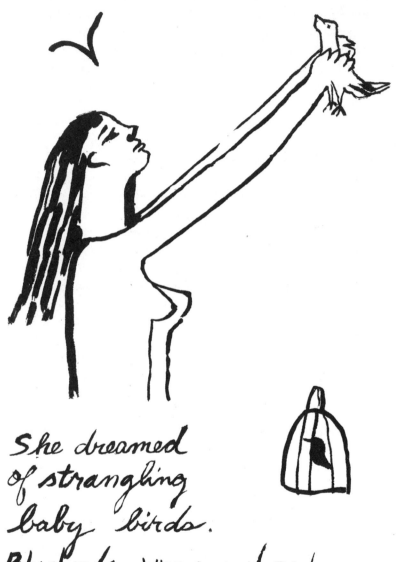

She dreamed
of strangling
baby birds.
Bluebirds wrens and robyns

Like when Martin died. Like when Ethyl died. Like when Desi Arnaz, Liberace, Danny Kaye died. What is happening to all of my heroes? And Desi will never get back with Lucy. All of my boys are dying on me. Oh, I wish I could relieve you of your pain. Oh, I wish I could relieve you of your suffering.

Like when my father finally told me he loved me after forty years, then went into the bathroom, locked the door, put up pictures of children from the Sears catalogue, arranged mirrors, black stockings and garters to look at as he masturbated, as he hanged himself from the shower stall. It's that ultimate erection. It's that ultimate orgasm. Whatever turns you on, girl. Whatever, whatever turns you on.

And when that man died, volcanoes erupted, cyclones appeared, coyotes came out of their caves, old people were struck by lightning. Don't you know that I don't want any more deaths on my conscience?

For I already have an abortion on my conscience from when a member of my own family raped me. Don't worry, I won't mention your name. Don't worry, I won't mention your name. And I know now that the reason why my father committed suicide is because he no longer found me attractive.

And by now you can tell that I prefer talking about the fear of living, as opposed to the fear of dying.

ENTER ENTREPRENEUR

I hate yellow. I hate any signs of spring. Don't you know I'm only happy when I'm depressed? Don't you know that I'm only happy when I'm wearing black? That I'm only happy at night. Yes, I'm a creature of the night. I see you coming into my neighborhood with your new car, your new teeth, and your solid pastel lime green puke green pale pink apricot shirt that goes together with everything, catching sales as you go, with the Gap as your mascot. Well, I'm here to tell you the Gap is the devil. Having everyone look as inoffensive as possible, having everyone be as together as possible— though the wearer is as offensive as possible on the inside. You want everyone to look the same, so maybe they'll feel the same and then they'll be easier to control, to take over.

So, you come into our neighborhood, into our lives of ethnicity, of difference, of poverty, of artistic expres-

sion, and you come into my neighborhood trying to co-op, trying to condominimize our lives so you can make a big real estate deal. Well, I'll be your conscience.

So I took too many sleeping pills and nothing happened.
So I put a gun to my head and nothing happened.
So I put my head in the oven and nothing happened.
So I fucked you all night long and nothing happened.
So I went on a diet and nothing happened.
So I became macrobiotic and nothing happened.
So I went to all the Big City nightclubs and nothing happened.
So I tried to get into the art scene, went to Soho, and nothing happened.
So I went to college, never paid back that student loan, 'cause I knew nothing was gonna happen.
So I quit booze and drugs but nothing ever happened.
So I became kind of political—I worked for ERA, I voted for Jesse Jackson—but nothing ever happened.
So I decided to become domestic—I cleaned, cooked, and put out roach motels—but nothing, nothing ever happened.
So I petitioned, rioted, terrorized, and organized 'cause I'm gonna make something happen.

I'm not gonna let you gang rape me any more, Mr. Yuppie, Mr. Businessman, Mr. Entrepreneur. I'm not going to let you take my streets that I built with my soul, my creativity, my spirit. You just look at all of my art, Mr. Bucks, as another investment deal. My sweat, my music, my fashion is just another money-making scheme for you. You are the reason why David's Cookies and McDonald's are the symbols of my culture. You

are the reason why fast food is the only growth indus-
try in this nation.

So you come into my neighborhood, after your nine-
to-five job, on weekends, looking for the artistic experi-
ence. So you can go back to work and show off that
you've experienced bohemia. I'll be happy to show you
the artistic experience. I am the girl for the job.

So I take you, Mr. Entrepreneur, Mr. Yuppie, Mr.
Yesman, and tie you up in all of your fashion, your
Calvin Klein, your Ralph Lauren, your Anne Klein, too,
your Bloomingdale's, your Macy's, and I tie you up in
it, I tie you up in all of your pastel cotton shirts of lilac
and mint green and you know what? You like it. And
Mr. Yuppie says, "Is this the artistic experience?" and I
smile and he likes it, he likes it.

So I open up those designer jeans of yours, those
Girbauds (I even got a pair too). Open up your ass and
stick up there that sushi, that nouvelle cuisine. I stick
up your ass that Cuisinart, that white wine corkage
charge, that raquetball, everything made by Braun and
Black and Decker. I keep sticking it up there 'cause
there's more room. So Mr. Yuppie hands me his
Walkman and cordless phone, and I put it up there too,
and he likes it, he likes it. But then Mr. Yuppie looks
up at me worried and he asks, "But where's the graffiti
art?" And I just laugh and say, "It's up your ass." And
he smugly smiles like he got something for nothing
'cause he works all day stealing from the poor and he
wants some of that artistic experience for his resumé.

I know you want to experience the inspiration of the
artist. So I take your Yuppie body and drag it down

8

Avenue B and let your tongue roll along the street licking up the shit and piss, the sweat and blood of me, and you know what? You like it. You like it. Then I make you lick the tires of your BMW. Then I leave you on the corner and steal your BMW 'cause I know nothing is going to happen.

So I drive down the street at full speed. Scare to death anyone who looks like they hold a political office, anyone who looks like they own private property (I'll show you the burden of private property), and anyone who wears a suit. 'Cause according to Mr. Andy Somma, suits and rock 'n' roll don't mix.

I drive down to Wall Street and break into the Exchange. I go up to all the traders and cut off all of their balls. They don't bleed, only dollar signs come out of them. They don't miss their balls 'cause they're too busy fucking me with everything else they got.
So I gather all of their balls, their scrotum, their testicles—oh, I love the word scrotum, say that word again, scrotum, yeah, scrotum—so I got all these balls, I got hundreds, I got thousands, and I stick 'em in my mouth, roll 'em around in my mouth and I feel like a squirrel in heat. I take all the BBbaballs and I throw 'em in my BMW and everyone thinks I'm so nice, like I'm a future entrepreneur and I'm going to start my own donut hole stand or dim sum store. I take the balls home and boil them 'cause they're small balls and need to be plumped up. Just like you guys like your tits big we girls like our balls BIG. So I boil the balls till they're big big balls. Then I take a big, steamy shit and roll the balls in my own manure, my own dung 'cause I'm the High Priestess of the Dung Dynasty. Then I melt some Hershey's kisses and roll the Dung eggs in it. Then I

gather all the fancy silver-foiled cigarette paper from Eurotrash folk or from academics who think they know everything from reading. Then I roll the scrotum— manure chocolate-coated balls—into the the fancy shiny paper. Now I go sell my chocolate eggs to Godiva or gourmet shops for one hundred dollars a pound. Oh, I get my revenge. Oh, I get my revenge.

Lord, God in heaven, why don't you appear to me now?

Is it because you're a man?

Whatever happened to the Tooth Fairy? Whatever happened to the Easter Bunny? Whatever happened to Andy Warhol?

Dead, girl. Dead.

I know I live in a dead-end time. I know I got dead-end housing, a dead-end future for my kids, I know I got a dead-end job. I got a dead-end culture, it's a dead-end world. I know, I know it's a long, long dead-end road.

TWO STORIES

J oanne. Joanne sleeps with a gun under her
pillow because every time she has intercourse with her
husband he defecates uncontrollably as he has an
orgasm. And the shit isn't a good solid shit brick
torpedo style crap. Oh no, it's that loose, runny, diar-
rhea shit that splatters all over the room. Even though
she puts Hefty trash bags all over the room, the car-
pets, the walls, lets the crap dry before peeling it off of
the plastic each morning, even though he pays all the
bills and spends time with the kids—SHE'LL TAKE HIS
CASH BUT SHE WON'T TAKE HIS SHIT! So she takes
her gun and sticks it up her husband's asshole just as
he is about to cum. The gun up his ass gives her such
a sense of power, and for a few fleeting moments the
tables are turned as she forgets the time when she was
forced to perform fellatio at gunpoint in front of her

11

own children and pets. And afterwards all her loved ones, family and neighbors could say was, "You're so lucky he didn't kill you and your children. You're so lucky that it didn't happen in the house. You're so lucky your children weren't harmed."

And father, when I said goodbye to you before I went off to war on that Christmas Eve, you were too busy with your head in the toilet to reply. I just wanted a father's recognition of his son, me. A hug, a goodbye, an approval, a son turning to a man. No, that would be too much for you. You just had to puke your gin, your rye, your whiskey in that toilet bowl. And I never forgave you for that.

They sent me to Vietnam on that Christmas Day to clean the blood off a dead man's gun, to sleep with a dried wound for a blanket, and to eat a meal of gray. Every man, woman, child I killed was my father's face in that toilet. I prayed that I'd die before my father so that he would feel guilt, but of course the bastard died before me. It's always like that with loved ones. They always die before you. They plan it that way.

I told myself it would be different when I had children. We'd share our experiences and feelings together. We'd be so close. But I'm just like my father, a drunken slob. And the only feelings I feel are just no, no feelings at all. The only feelings I share are no feelings at all.

COMMON SENSE

It was really Freud's problem to begin with.

Really. You don't say.

Yes, rumor has it that Freud had been sleeping with his daughter and sister-in-law on numerous occasions.

I knew it. That beard and that book on cocaine. I always thought the guy was nothing but a pervert. Do you know the money my family wasted on analysis?

What I wanted to bring up today, though, is that all fetuses are innately female for the first six weeks.

Is that so? Then that means that perhaps the penis and scrotum are merely an exaggerated clitoris and labia?

Perhaps, that is a way of looking at it.

Well, I hope you're not going to tell me the theory that woman was man's first possession?

Oh, no. I wouldn't dream of saying that. I merely wanted to suggest that it wasn't love that motivated man but the need to possess and master!

Isn't that a little harsh? I mean I'm trying to raise children here.

The truth is harsh. You don't want me to be a liar do you? What are you making for dinner tonight?

Richard's favorite, Hungarian goulash.

Well, count me in. Do you enjoy your women's studies classes?

I love my women's studies classes. The books, the women. I love finding out the reasons why I feel the way I do. BUT IF MY WOMEN'S STUDIES CLASS EVER GOT IN THE WAY OF MY BEING A PROPER HOSTESS FOR RICHARD'S BUSINESS, I'D GIVE IT UP IN A MINUTE. I'D SACRIFICE ANYTHING FOR MY FAMILY, TO THE POINT OF BECOMING A BORING AND PHO-BIC PERSON!

Is that why you have headaches?

I'm sick and tired of you asking me about my head-aches, my ways, my life. Don't you know that my

illness is my only form of nurturing? The only attention I get around here? My disease is my life, my health. Sure, I take Valium, but how can I look at my daughters and sons and try to dispel the myths that have been a tradition for centuries? Just to say, "Sure, we're all created equal"? I've never been treated equal my entire life. I'm supposed to be excited because museums are finally including a few women in their selections, because there is a woman on the Supreme Court. WOW. Yeah, big fucking deal. Have you ever listened to the classic rock radio stations? Women are absolutely excluded. Yeah, free at last. Free at last. You can read your fucking books. But nothing's changed. Nothing has changed.

So let me continue. The one thing, then, that man could not destroy was woman's ability to produce children that love her unconditionally. And even though the man was stronger than the woman (slave) he could not destroy the bond between a mother and her children. And the father learned that he had to earn his child's love.
This must have made the man very jealous indeed.

No, that didn't make him jealous. What made him jealous was when he discovered woman's ability to have multiple orgasms. Okay, I know that some of you guys like to let us know that you can fuck more than once. But I need no time to refuel.

So maybe it's womb envy instead of penis envy.

Perhaps, but don't ever let them know.

Let me tell you about paranoia. Sixty percent of the world's fish stock is in danger.

Let me tell you about obsession. Grown men force-feeding young boys to produce the perfect shit. The perfect taste, the perfect smell, the perfect color, the perfect length, the perfect size shit. Let it drop and suck it back up. Let it drop and suck it back up.

Let me tell you about power. Being gang raped by a group of youths at the age of fifteen in the subway until they discovered my secret, that I was born without a vagina. They didn't want to fuck me in my other holes, so they just threw me onto the train tracks in their embarrassment and let the train roll over me. Then my mother came to my rescue with her arms over her head screaming, "I know the reason why God didn't give you a vagina—so you couldn't be violated in this way." I knew I couldn't be a mother and a whore and I couldn't go into religion 'cause God was a man, so I spent my life thinking of ancient times when virgins had babies and miracles happened to the meek.

We all discussed our psychological disorders. Gary had overdosed, fell into a coma and imagined tigers and angels dancing on his neck. Rachel feared she had cancer until she really did create it with her mind. Rita washed her hands all night long till her hands were chapped raw and bleeding and her flesh just washed down the drain. Jeffrey heard voices. One told him to marry Charles Manson, another told him to impregnate childless women, and the third told him to become Jodie Foster's bicycle seat.

THE FATHER IN ALL OF US

My First Sexual Experience

My first sexual experience was at the time of my birth, passing through the vaginal canal. That red pulsing tunnel, that alley of love. It's the smell of my mama. I'm nothing but a human penis. At the time of my birth I had an erection. I'm fucking my own mama at birth. It's the smell, it's the sight of my own mama that keeps me going.

So I spend my adulthood driving around in my red car, the symbol of my masculinity, looking for hot mamas with hot titties in hot laundromats dressed in gingham, the symbol of their martyrdom. I love to find a hot young mama with a bald-headed baby. A brunette, a pageboy. I love the smell of the dryer, the sound of the spin cycle, the sight of a woman working a machine. It really turns me on. Oh, it gets me going seeing a woman's body vibrate against a machine. I just take that mama and push her against

17

that washer. Then I take her baby, a bald-headed baby, put Downy Fabric Softener on baby's head, strap that baby around my waist till it's a baby dildo. Then I take that baby—that baby dildo—and fuck it's own mama . . . 'CAUSE I'M NOTHING BUT A MOTHERFUCKER!

I'M NOTHING BUT A MOTHERFUCKER!

Just putting the baby back to where it wants to go, back to it's old room the womb. Then I reach out for those titties to see if the bitch is still nursing, but she's nothing but a dried old sow. She's nothing but a dried old sow. Then I blacked out.

And it's twenty years later.

And I'm in my mama's house.

And my mama is sprawled out on the avocado green shag carpeting wearing her washed-out plaid housecoat. My mama is still watching all the stories on the TV— "Oprah" has some show on incest, "Dynasty" and "The World Turns" are on too. There is macaroni and cheese on the stove, fishsticks in the oven. Let me make your stick into a fishstick, the tartar sauce is free. No diaphragm cream needed here. There is tomato soup on the burner. She got safety pins pinned on her like rubber bands 'round a doorknob. What do ya pin up, Ma? What do ya pin up? It's always a mystery with my mama. Ooh, those pins excite me. 'Specially pins near sagging old flesh.

And she smokes her Pall Malls, she smokes her Camels. Flick that ash Mama! Flick that ash! Look at me! Look at me! You never looked at me! I'm back, mama. You never looked at me. No, you didn't. I'm nothing to you. So I'll roll my mama's belly onto the shag carpeting. She's still not looking at me as I roll up her dress to the small of her back. She's still not looking at me; she's just watching that show on incest. And I look at her fat thick thighs. And I slowly pull down her cotton Carters, they're all holey, pee-

stained and elastic gone. She never spends money on herself, wouldn't buy herself a new pair of panties. No, that's my mama. I pull down her panties and I look at her fat rumpled ass like a piece of uncooked bacon. My hands soothe her dimple flesh. I knead into her rear like I'm making bread. My mama! My mama, sweet, sweet mama.

Then I mount my own mama in the ass. That's right, I fuck my own mama in the ass 'cause I'd never fuck my mama in her snatch! She's my mama.

I cum real quick. 'Cause I'm a quick-working man. Work real fast. After I cum, I come outta my mama. I want my mama to want me but she don't ever want me. She's still just watching that TV. Just suckin' that Pall Mall. So I know what I want to do. I want my sauce back. So I go down on my mama and suck my own cum outta my own mama's ass, outta her butthole. Gotta mouthful of her own Hershey's coconut juice. Suck it out. Suck it. Pucker, pucker.

When I get a mouthful of that stuff, after I felch her good, I move my hands to my mama's face. I touch her red hair with its white streaks at her temples, her potato face. I can see the raspberry lipstick leak into the wrinkles of her skin. That space between her lips and her nose. What's that space called? I gently take the cigarette out of my mama's mouth 'cause if I got it wet she'd beat the shit outta me! She'd beat the shit outta me! I gently unseal my mama's lips and press my lips to my mama's. From the corner of her mouth I spit my cum back into her mouth. Like pearls from an oyster returning to the sea at last.

She just swallows the cum and says, "Boy, you got lazy ass cum. Just like your father. Your cum ain't salty. You can cum on my pancakes anytime."

Refrigerator

And the first, and the first, and the first memory, memory I have, I have of my father, the first memory I have of my father is of him putting me into the refrigerator. He'd take off all of my clothes on my five-year-old body and I'd be naked sitting on that silver rack of the icebox. My feet and fingers would get into the piccalilli, they'd get into the mustard, the mayo. You wonder why I puke whenever I see condiments. Why I never enjoy my food. Gotta up-chuck, gotta puke. And I got all my dollies around me. I'm holding on to all of my dollies. My arms hold on to my Barbie and Ken, my Aunt Jemima, my G.I. Joe, my Winnie-the-Pooh—all my dollies would protect me. All my prophets, princesses, and kings would stay with me.

Then my daddy is laughin'. Then my daddy is playin'. Then my daddy is gigglin' and smilin'. Don't you know I hate smiles and laughter. Don't you know I hate good times! 'Cause the only feelings I feel are no no no feelings at all.

My daddy stands behind the icebox door. He smiles wide saying we're goin' to play a secret game, for just me and daddy. Then he says never tell anyone. It's just our game. IT'S JUST OUR GAME. IT'S JUST OUR LITTLE GAME.

He slap slap. He slap slap. I don't know this game. I don't want to play this game. Then he smiles wide. I hold on to my dollies more. Then he leans down to the vegetable bin, opens it and takes out the carrots, the celery, the zucchini, the cucumbers. Then he starts working on my little hole, my little little, hole. My little girl hole. Showing me "what it's like to be a mama," he says. Showing me "what it's like to be a woman, to be loved. That's a Daddy's job," he tells me. Working my little hole. Hee. HEE. HEHHHEEE. HEE HUHUHU HUH. Working my little hole

20

hee hee hee. Working my little hole hee hee hee.

Next thing I know I'm in bed crying, bleeding. I got all my dollies and animals around me. I've got Band-Aids between their legs. If they can't protect me, I'll protect them. If you can't be there for me, I'll always be there for you. I'll always, I'll always be there for you.

Then I hear my mama come home. And she starts yelling at me at the top of her lungs. "Whatever happened to the vegetables for the dinner for tonight? Whatever happened to the vegetables? You been playing with your food again, girl? I was going to make your father's favorite."

I just want to scream out, but of course I can't, "Mama, open up your eyes! DON'T YOU KNOW THAT I'M DADDY'S FAVORITE?"

And I just cry to myself. Is this what it's like to be a mama? Oh, no. Is this what it's like to be a daddy? Oh, no. It's just being part of the whole human race. Ssh, now. Ssh, ssh, child. Ssh. Hush, child, go to sleep.

Father In All of Us

I'm your eldest son. I'm your middle son, your youngest son, and I'm named after you, Father. I'm your son, named after you. Your name.

When I finally told you after years of searching that I, your son, was in love with another man, that I was in love with Louis, that I was in love with Charles, you didn't believe me 'cause you were never in love before. Love didn't make the world go 'round for you. Prestige did. What others thought did.

I decided to go with love and leave you behind. I hadn't seen you for years. You had disowned me for the honesty of my sexual preference, my sexual origins, for being me. You call yourself a doctor man, a man of compassion, a

reliever of pain. I knew I couldn't come to you as a son, so I'd come to you as a patient, and if I couldn't come to you as a patient, I'd come to you as a human being.

When I told you that I had the disease that afflicts some homosexuals—women and children too—I knew you would no longer consider me your son, a man, so I went to you as a human being. And all you could say to me in your white lab coat was, "I told you to stay away from all those faggots, those queens, those queers, those fairies, those people with the lisps. I told you to get out of San Francisco. I told you to get out of New York City. I told you to get out of Miami. I told you to get out of New Orleans, Ohio, Montana, America. Out of Europe and Africa and Asia. Get out. Get out!

Oh Father, Father. You wonder why I send you a crate of shit each day. You call yourself a doctor who relieves pain. Man, you've been giving me nothing but pain since the day I was conceived. You call yourself the provider, the money man, the punisher. Baby, you sure been punishing me.

When I died, you didn't announce my death. Oh, no. You just called it accidental, cause unknown, cause uncertain. How could you have announced my death when you never announced my life? Not even a proper burial. Not even a mourning for those who loved me. Oh Father, Father. Your fucking reputation! Call him the provider, the punisher, the money man.

I'm going to curse you, Father, till the day you die. Going to curse you from the grave. Blame you, and God too. You might take away my body but you can't take away my soul, my spirit, my mind. For my spirit is stronger than my flesh. My soul is stronger than my body. It's the father, the father in all of us.

It's the father in all of us that gave us the Berlin Wall,

that saves the whales, makes treaties, makes decisions and reasons, makes bridges and tunnels, cures and diseases, ways and means, politics and social disorders. It's the father, it's the father in all of us.

And I pray to you, Father in the sky, every night, "Father, make me feel wanted. Oh, let me gain that unrequited love!" Oh, it's the father, the father, the father in all of us.

Abuse

After I fist fucked you with my handful of sapphires, emeralds, garnets and opals . . . I was fucking you with my aquamarines, my gold, my silver and platinum. I was fucking you with my will, my property, my esteem, and my values. I was fucking you with pearls and diamonds. Just filling your hole with everything I got. I was fucking you with my talent 'cause it's all I got left. My rings just cutting you. Your snatch on liquid fire. I just look down on you. You just look up with your doe eyes and say, "It's better to feel abuse than to feel nothing at all." I just collapsed on your pregnant belly and vomited because I saw the president on TV.

I had to go out and get some air. I walked down the street and saw you lying there on the sidewalk encrusted in filth and neglect. I walked right over your baked body in the cement. My heel caught the needle in your arm and tore your flesh with my walk. I knew you once. I had been in love with you once. I knew you when you were going to do great things for us. You had been very talented, but now you are worthless 'cause in this town it's every man for himself. Because in this town you just got to do what it takes to stay at the top. Such a big, big town. Such a small, small city.

I remember the custom of our nation during war—of tying the enemies' pregnant women's ankles together during birth. Such a civilized people. Such a great land. Such a civilized culture.

White Man's Guilt

The one thing we felt was missing from our lives was a religious experience. We had been everywhere. We knew many peoples and places, and had visited other cultures. We had great rewarding jobs we liked and that paid well. Of course, we had been to school many, many times. Somewhere we had children too. But the one thing we were missing was a religious experience.

While reading *Gourmet* magazine we had discovered that Arizona was the best place for a religious experience. Not in Phoenix, of course, but in Tucson. We flew my jet out to the desert and we all stayed at the Old Hotel Continental. We were told Dillinger had stayed there once. We all drank and talked in the local hotel bar. I was very pleased that the walls were filled with hobo art because I was sure this would prove to be a strong art investment for the coming fall.

So we all piled into my '73 maroon Maverick. The color and style would blend so well with the region. There was Peter, who loved too much, to the point of being violent. (So he had to stop his loving, but that didn't solve his problem.) There was Maureen, who once was a great contact-improv dancer. But she could never find content in her work; she always felt she was just doing sports. Now she just sold pot (and let me tell you it was the best damn pot in the world). Then there was Nick. His problem was that his life had been too easy and he blamed everyone for it. Then there was Irv, a local, who rarely left town except

to go to funerals. Then there was me. My problem was that I knew too much. I knew what everyone should do with their lives. But I didn't know how to take care of myself.

So we all drove out on that full moon night, All Souls' Day, around midnight. Yes, we had planned it that way. We wanted our religious experience to go just right that weekend (I had to be back by Monday for an appointment with my accountant, and he was very hard to get an hour with). We drove and drove into the desert. Maureen had read a Carlos Castaneda book, or was it Alan Watts, and she felt this was the best procedure. We continued driving till we came to an Indian reservation and we found a huge seventeenth-century basilica that looked like a wedding cake in the sky.

We stopped and walked toward the church. To our surprise it was open. We never thought of prayer being available twenty-four hours a day. In the chapel, there were statues, altars and candles. I took out my VSOP cognac, which I had bought in the south of France. It was a tremendous cognac, full-bodied and luscious. While I was pouring the liqueur I noticed snapshots and letters on the altars. They were prayers and hopes to saints and gods and heavens.

Letters that read: Please let my children be returned from the kidnappers unharmed. Please let my son have a new leg. Please don't let them cut off both breasts—I don't know how I'll feed my babies. I need a few more dollars to feed my family. My house burned down and no one will take us in. My mother drinks so much she doesn't know what she does. Lord, I can't see, hear or speak. Thank you for letting me feel. And our lives seemed so meaningless. We just had to get out of there.

Outside, there was a cemetery, an Indian cemetery. The graves were all decorated with flowers and paper lanterns because it was All Souls' Day, and candles illuminated the

earth. We never knew death could look this way. Death—we were taught that death means the end, blackness, nothing more. The more we walked through the graveyard the more we knew our sadness. ALL OF OUR MEN WERE DYING ON US. ALL OF OUR LOVED ONES, OUR FRIENDS WERE DYING ON US. And we felt so out of control. We thought the country would do something about it. We thought this culture would do something about modern plagues.

I started looking for my friends. Dead friends. "Johnny, Johnny. Give me a sign. Let me see you," I cried out to him. "Oh, Daddy. Oh, baby Corey. Let me see you. I want to know that life is more than an illusion." We were going to do so much. We were going to change the world. Whatever happened to our talents? Whatever happened to our dreams? I feel all alone. I feel everything is meaningless. There is nothing to live for.

Then a wind, a chill overcame me, and the wind, the spirits whispered in my soul. "Work from the heart," they said. And I knew everything I had done meant nothing. I wanted to see the invisible.

We all walked back to the car, drove back to the hotel, and we were all feeling the same thing—White Man's Guilt. Guilt for giving a truck and a house with no plumbing to every American Indian family.

The FAMILY THAT NEVER WAS

THE FAMILY THAT NEVER WAS

THE FAMILY THAT NEVER WAS

Mother, do you have a prick?
Yes, I do. Just like cows do.
After my mother washed me, powdered me, I insisted
that she masturbate me.
You wonder why I have panic attacks.
And you dreamed you ate me through my
silken panties.
But baby, you got it wrong. I don't smile when I come.

When we go on vacation we always stay at the Neon
Kon Tiki Motel. The motel is decorated in a Pacific
Island motif, and they even have orange telephones. In
the motel room we could hear everyone fucking. Not in
the room but upstairs, downstairs, next door and down
the hall. Short fast bangs. Moaning, moving, fucking

groans. Short fast bangs. Motel beds screwed in the wall fucking. We didn't fuck like that at home.

As we walked around our room we puffed on BelAirs and listened to the fuck sounds. Later we'd go down to the lobby and try to match the fuck sounds with fuck faces. Whatever turns you on, girl. Whatever, whatever turns you on.

He loved to wear silk knotted scarves around his neck. He'd finger and stroke the silken knot. He sold silk scarves at a Madison Avenue store. I'd watch him and imagine him masturbating me with his silken scarves, gently rubbing the silky cloth along my thigh, my leg, my genitals. Then, just as I was about to come, he'd perform a magic trick, pulling a hot, oiled, knotted scarf out of my asshole. Then I'd fall to my knees in ecstasy, looking up the skirts of uptight holiday shoppers in Bloomingdale's.

In the old Thrift Shop in Old Phoenix we found a lamp, a chandelier made out of gray cardboard egg cartons and marbles. We didn't purchase that item, but instead I bought a circular, handmade, crocheted, lace doily with pink rosebuds on the edges. Oh, I love pink rosebuds because they make me think of a man's erect nipple. Oh, I love to suck a man's nipple. Oh, I love to suck a man's nipple. I love men who like to have their nipples sucked.

When I brought the doily to the cashier in the thrift shop, I noticed that the cashier kept a clear glass jar on the shelf behind him. It must have been a mayonnaise jar minus the label and it was filled with water. A rock

was immersed in the liquid.

When I asked him about this practice with the rock in a jar filled with water, he didn't answer me. Instead, out of nowhere appeared stones and crystals and gems and minerals from pockets; wrists were emptied of slivers of slate, pebbles from Lucky Strike packets. Large lithics, pale lumps of olive and dawn colored earth.

Yes, he collected rocks.

He also buried them.

He told me that you never know when you need a rock in this life, in this town, when you need a part of this world. I couldn't argue with him there.

I thought he was such a fine man because he told me that on weekends he would go out to the desert with his son and bury the specimens, putting them back where they came from. I knew this was very rare, for most men rape the earth like they rape their women. He had been a doctor once, a surgeon. I'm sure he had been a very fine doctor. But I didn't bother to ask him, if he had been a doctor, why he was working as a cashier in a thrift shop. 'Cause you just never know what happens to someone in his life. You never know what happens to someone in his life.

That's why I say, Whatever it takes to get you up in the morning.

Whatever, whatever it takes to get you up in the morning!

So when people ask:

Why do you spend so much money on taxis?

Why do you spend so much money on clothes?

Why do you always eat in restaurants?

Why do you live in such a bad neighborhood and pay such high rent?

Why do you drink all the time?
Why do you only spend time with your friends and not
with your family?
You just look 'em straight in the eye and say:
'Cause it makes me happy!
'Cause I get a kick out of it!
'Cause I enjoy my life, not like you,
Always saving, living a boring, cheap, ungenerous
lifestyle for a future that'll never be.
So the next time you go to visit your family for the
holidays or some other celebratory occasion with your
last hundred dollars and the first thing that comes out
of their smiling mouths is:
HOW CAN YOU LIVE LIKE THAT?
We worked our asses off for you to be doing that with
your life?
HOW CAN YOU LIVE LIKE THAT?
You call that a career?
Just look them straight in the eye, smile and say:
Easily, just as long as it's as far away as possible from
you!
'Cause I'm giving my life everthing you didn't give me:
FUN! PLEASURE! LOVE WITHOUT CONDITIONS!
GENEROSITY AND HELPING OTHERS.

I say, either go home to visit your family knowing that
as an artist it's good material, or just don't go.

You see, I'm lucky because I usually get kicked out of
my family's house before the big holiday dinner pow-
wow, so I don't have to sit with a roomful of emotional
derelicts that look like me.

There's my mother, who likes to saw the legs off of furniture to relieve stress. There's my brother, who has not forgiven me in twenty years for making fun of him for eating his boogers. I try to arrange "appointments" with another sibling when she is in between bouts of depression and making money. Another relative listens to the Grateful Dead but voted for George Bush. Yeah, I sit with a cast of thousands. I know I have a disorder. . . . It's a family disorder. It's the order I was born in.

And you know what story you'll hear if you make it to the Big Dinner? It doesn't matter what your background is, where you come from. It'll always be the same story: The Dead Pets Series.
Lady was such a good dog. There never was a dog like Lady. I have never seen a dog like Lady. She was such a good dog up until the last three months of her life when she was shitting and farting all over the house. We had to throw out the rugs, furniture, it was all over the house. In fact, we just gave the whole house to her 'cause we loved her. She protected the family like no other dog. She protected the garbage can lids. And what a mother! I have never seen a better mother than Lady. This dog was a better mother than most women are.
Do you remember when Lady had puppies and they were all born dead? We couldn't take them away from her 'cause she was Lady. Then she hid them around the house—behind the refrigerator, behind the radiator, under the carpeting. We had to go on vacation then 'cause Steve only got two weeks off and when we returned the whole house smelled of DEAD PETS! We loved her. We loved her. She was Lady. She was Lady.

Fluffy the Cat. Fluffy the Cat. There never was a cat
like Fluffy. Do you remember when Fluffy was puking
and shitting the same color as that brocolli you're
eating right now? In fact, this cat loved me so much
that when her shit got stuck and I had to pull it out
with chopsticks and ice prongs, she let me do it. 'Cause
she's Fluffy. And it was a piece of brocolli stuck in her.
Then we found out she was eating her vomit off the
avocado shag carpeting. Oh, Fluffy.
We resuscitated the bird. We resuscitated the bird.
Gave it mouth to mouth.
The lizards. They fried up on the aquarium lamp. Just
peeled 'em off the light bulb. I kept them, of course. Put
them in the bible for show and tell. I'm such a good
mother. I'm always prepared.

You know the other thing loved ones always like to do
is die when you don't want them to. They always die
when it's the most important time in your life, or when
you're celebrating the holidays. They plan it that way.
Like when my grandmother died on December 23, and
my mother went to the funeral home and cried, "Keep
that bitch alive a few weeks longer! She's not going to
ruin my family and my holidays for the rest of our
lives."
"I can't carve that turkey without your father here."
"I can't put that star on that tree without your mother
here."
"That bird flapping its wings against the window is
your aunt. That spider in the sink is your uncle. I want
to see a sign. I want to know you're on the other side.
Let me see you. My holidays will never be the same
without you!"
Why don't they just get it through their heads that

they're so lucky to be out of here. That they are angels, stars, and moonbeams. That they are so lucky to be out of here.

Yesterday, I found out my friend didn't die but that my dog died.
Today, I found out that my friend died after all. That's why I like reading books about reincarnation and the 4th dimension. I like the idea that life is merely an illusion.
My dog was taught not to fear pain. The cancer crept through her intestines until her stools were black with blood. A friend told me that I had caused the cancer, that I had killed my own dog by not loving her enough, by not feeding her enough, or by leaving her alone too much. Isn't that what friends are for? Leave it to your loved ones always to speak kind thoughts.

You said there were to be no more theme parties. There were going to be no more places just to act silly.
Then it began to snow.
This year would be different, I thought. Since I was all alone I would still try to celebrate the holidays as best I could. But I'm all alone, all alone. I wanted to celebrate each holiday to the maximum. But I can't wear a costume. I don't want to wear a mask, for my whole life is just one big costume.
Last week my friend asked me to lie. I couldn't lie. I lost my friend because my whole life is just one big lie.
Last week I found out my ex-husband is getting remarried. His life is a lie too.
And maybe, the child who fell down the well in Texas just wanted to be there. Of course, no one bothered to ask.

What are you dreaming of?

As she nursed her baby the mother would always put the child's leg into her vagina. The G-spot was always found.

What are you reading?

That half the population of butterflies in Holland has disappeared in the past few years.

What are you afraid of?

I'm afraid of growing up and being run over by cars.
I'm afraid that my mother never appreciated me.
I'm afraid that my mother never said I love you.
I'm afraid that my country, my culture is over.
I'm afraid all my friends are gone.
I'm afraid all my friends are dying on me.
I'm, I'm afraid. I'm scared.
I'm vulnerable. I feel knives being thrown at me, comas, cancers and eternal suffering.

What else do you feel?

Prominent and persistent sadness, hopelessness, apathy.
I just feel numb all over.

Why?

I feel so guilty that I didn't die.
I feel so guilty that I didn't die instead of you.

I feel so guilty that you were sick and I wasn't.
I feel so guilty that you died, you died, you died.

What else don't you like?

I don't like the fact that most museums and art galleries only show WHITE MALE ARTISTS.

And what else don't you like?

I don't like convenience. I don't like anything open 24 hours. I don't like the fact that I can buy anything at all times. I want some time off. I hate convenience markets, White Hen Pantries, 7-11s. All night fluorescent glow stores.

I just love to go into a 24-hour store and get the cashier, who looks like some blonde floosy all dressed up as if it's prom night or the inaugural ball. She's at the height of her feminine passivity, the height of her desirability, working in that convenience store.
I get behind her as she's checking out express. I have her walk all over me in those high heels. Make me black and blue. Then I throw her against the Slurpee machine. Then I make her wear a wet T-shirt that says Spuds MacKenzie on it.
Then I make her get on all fours and bark like a dog. Then I say, "ACT LIKE A FUCKING PARTY ANIMAL NOW, BITCH! ACT LIKE A FUCKING PARTY ANIMAL NOW!" Then I look down at that blonde bullshit and I ask her, "Why do you dress that way? Why do you wear your hair that way? Why do you wear that makeup? Don't you realize that you're only a cashier in a Convenience Store? Your life is boring. You live in the suburbs, in a mall. You're life is meaningless!"

And she just looks up at me and asks, "How can I make my life more meaningful?" And I say, "Like this!"

I turn her over and take her head with all of that blonde fuzz mop hair and stick her head into the aluminum bucket of ammonia and suds and mop the entire floor with her head. That's all she's good for. Then I fuck her as I mop the floor with her 'cause I come from the city with big shoulders and I like to do two jobs at once. The bitch doesn't say anything 'cause "General Hospital" is on.

Then I drop her in front of the dairy case because I see the reason why my city is over with—this dairy case is bigger than most New York City apartments! Then I see what's in those dairy cases. It's that Frugden Gladge, that Haagen-Dazs, that Ben and Cherry Garcia ice cream bullshit that's ruining my culture. That $12.99-a-pint cream. Then I open up all the cartons of ice cream and I piss in 'em, I jerk off in 'em, I fart in 'em. I go into little kids' butts and take their turds and put it into that chocolate-macadamia stuff. I stuff it back into the freezer and go back and stand at the great temple of our culture, the video rental counter.

I stand by the counter and wait for all these boring white people in their Camaros, their frosted-flake hairdos, from their nine-to-five existence, totally igno-rant of the collapse of society, and everything is fine as long as they get that video, as long as they have that car, that stereo. It doesn't matter what they do for a living, what is happening in the world. They come in their yukfits, they come in and rent *The Color of Money,* *Top Gun, Rambo,* and they think they are on the top of

the world 'cause it only costs 99 cents. This is the time of their lives. They think they are so cool, buying another thing, just keeping up with the fashion.

Then they go and buy a carton of me, have a taste of me. I get my revenge. I get my revenge. I go home and take a hot bath of hot piss, masturbate to Ollie North and tuck my little girls into bed 'cause I'm a good parent. I get my revenge. I get my revenge.

What makes you happy then?

The fantasy that the stock market would really crash.

The Xerox room is a mess! The Xerox room is a mess! What the hell are you doing Xeroxing your erect penis on the Xerox machine?

Listen, Lady. It's all over. The party's all over. But my part has just begun. I say fuck IBM. I say fuck GE. I say fuck the gas company, the electric company. There are no more reports to Xerox 'cause there are no more companies left, which means there are no corporations left, which means no more bureaucracy left, which means no more bullshit! The only companies that didn't go under were thirteen condom companies, one Korean market and one hot dog stand. Coops, Condos, luxury vacations, gone. Two cars, swimming pools, out. BMW's, Cadillacs and Audis too. I never knew 'em. Restaurants that sold Third World food at yuppie prices, gone. It isn't the death of downtown! It's the death of Uptown!

And you know who secretly loves the thought that there really could be a crash, a recession or depression?

40

Our grandparents and parents. Then they could finally bring out all their stories of the Great Depression.

They really believe that if we had some real economic suffering we would have such healthy lives like they have. And the stories come out: I walked ten miles to school barefoot in the falling snow after I worked all night in a bakery lifting one-hundred-pound bags of flour on my sixty-pound frame. The only nourishment I received was the sweepings from the floor. We had to burn all the furniture to keep warm. I had to run after coal carts to gather pieces of dropped coal. My mother had TB. Everyone had polio. Everyone was afraid of swimming pools. Receiving an orange at Christmas was a big deal. Receiving a new pair of socks was even a bigger deal yet. Then we got the New Deal. And amidst all of this I was an A+ student. But then the war came. I never became what I wanted to be, which was an artist, a musician, a philosopher. Instead, I became a dentist.

My entire life has been unhappy. I didn't have money as a child and then as an adult I had money and I still wasn't happy. That's why your mother and I had you. You were to have everything we didn't have, to be everything we couldn't be. A free spirit. A new generation of world and life experience. You would travel, meet new people, go to school for something else other than a career. We wanted you to expand yourself in a way that our generation wasn't allowed. You could have a job that you enjoyed, for which you had talent and gained respect. We wanted our children to be the new caretakers of the empire. There were to be no more wars.

YOU WERE TO BE OUR ENTIRE EMOTIONAL EXPERI-
ENCE FOR THE WORLD. But while we were out getting
things for you we forgot about your heart, and now that
era is over.
You see, the government never liked us. The system
always wanted to kill the seer, the visionary because—
WE BITCH
WE MOAN
WE COMPLAIN
AND WE PROTEST.

They've tried to take our cities away from us with their
real estate.
Well, baby, let me tell you about the real state of life!

I'm a person of spirit
I know the 4th dimension well
I speak to souls from other worlds
I work from love

And the system is not going to bring me down.
They've broken my heart by inventing a disease that
has taken away the most creative players of our gen-
eration. Tried to scare us women from reproduction.
The Yuppies tried to buy the dream, tried to go quietly
with capitalism and then it was taken away from them,
too. Yuppies, money-makers—now is your chance to
turn back to the fold. Turn back to the generation that
refuses to compromise, that refuses to grow up in a
materialistic, greedy, cruel nation.

But it doesn't matter, for the bohemians, the dream
makers, have been living the revolution all along.
I'm so happy that companies have karma too.

42

I could give a shit if companies lost money in the stock market.

I could care less if AT&T lost money in the stock market 'cause they never cared about me when I lost money in their phones.

I could give a fuck if General Electric stocks went down 'cause they never cared about me when I needed a few more days to pay my electric bill.

And IBM never gave me a break.

These companies didn't help me when I was eating out of cans. These companies didn't help me when my father shot himself 'cause he was in debt and the IRS took our house away. No, these companies didn't care about me.

No. But you were there for me.

You were always there for me.

You were always there for me.

And I'll always be there for you.

Like you were there for me.

We will always be there for each other.

QUOTES FROM A
HYSTERICAL FEMALE

QUOTES

FROM

A

HYSTERICAL

FEMALE

SUSHI PARTY

The Women Entertain the Average Ass Man

How long have you been attached to your misery?
As long as I've had these big fat thighs.
Why do you spend so much time painting your nails?
So you'll know I'll spend a long time on your tool.
I see you from across the room in that beige man T-shirt. Us girls won't go out of the house dressed like that. You are a boy with those boy smells. I just have to go up to you and ask when did you throw out my phone number, before or after you got home?
Doctor, you touched my vertebrae and you are touching my unpaid bills, touching my unmade marriages. And you look at me and say, "Have you ever had shock treatment?"
And I say, "Doctor, life is a shock treatment."

The first thing I'm going to do this year is raise the price of blow jobs. When you're lying on your back with your legs apart, that's no work at all. But if you want me to swallow your cum that'll be an extra fin.

This year we broads, bitches, dames and chicks are going to have the New Year's Eve Party. Boys, we decided we are going to have the party at our house down by Kenosha, down by Oshkosh, down by Schaumburg, down by Niles, we'll have our party.

We get our big glass punch bowl, that big glass bowl like crystal, like plastic. I get myself a bottle of gin, bottle of crème de menthe—make it green—Grand Marnier, crème de cacao, Jack Daniels. And I put Wild Turkey in that punch bowl. Put the white wine, the chablis, and the Sprite over the ice cream that I get from 31 Flavors to give it some head. Like licorice whip, macadamia, chocolate macaroon flavors. Then I clean out the medicine cabinet and I put in the Tylenol, aspirin, ampicillin too. (I don't ever put penicillin in because someone might be allergic.) I also take some wart cream and some Hawaiian sensemilla and make a paste with some maraschino juice and put it on the rim of the glasses like salted margarita glasses. I've got my diarrhea pills; I've got my codeine, my ups and downs. I put all of those pills in the punch and then, baby, me and my girls, we get the ecstasy and the dust and the acid, about a hundred tabs. I clean out the entire medicine cabinet and put everything in my party juice.

Then I go over to the cops because some of the tricks of us girls are cops. Cops get the best drugs. Cops get the best dust and smoke. We let our gums soak up our dusted, rimmed glasses of blow and cool juice. We let the

cops into our house for the party, for we give the best party. We give them some glasses of our punch, lots of glasses, until they are puking all over the place, all over the place.

The men are upchucking all over the place, and then it's time for our annual sushi party. Well, I open up a can of tuna and I put it into the folds of my vulva. Then I stand in front of the men, over the men, and then I say to the men, "SUSHI PARTY BOYS! EAT UP!" They are all out of their minds from the pills and the puking and they are chewing me, chewing me. Then they say this isn't like usual tuna, it's kinda juicy and soggy. Sushi, sushi, juicy sushi. And they are eating me up. I've got my party going.

The next thing they're doing is pooping all over the place, throwing up all over the place. They've lost control. I don't care 'cause I have Hefty trash bags all over the place, taped all over the carpet. Mildred doesn't care 'cause she's got her Electrolux to clean it up. But I say, "Wait till tomorrow, Mildred. It peels up like Elmer's Glue." She's my best friend and we girls know how to have a party. So she takes out the Electrolux. Fred sees her with the vacuum and that turns him on. He wants to take that long long tube and work her oyster over. Just work her over. But this time the boys aren't in control. We're in control.

We are all laughing, laughing, and then it's my favorite part of our party. I go and sit over the boys faces and fart. Fart. 'Cause these men have been farting and passing gas every night. They go and have dinner and they pass gas, they get out of the dinner and they fart. They watch their sports and they fart. I keep farting on them until they say, "Please, please don't fart on me. I promise I won't fart and watch sports anymore!"

I'M AN ASS MAN

Her Body Puts Her in Trouble but Her Biology Saves Her

How do you survive with a child that drools and is
cross-eyed?

I treat him like a dog, you bastard, you bitch, you motherfucker.

When my kids say "FUCK YOU!" I turn them over and fuck 'em in
the ass. That'll stop their drooling. That'll stop their rhythmic
shaking. If they want to shake they can shake my dick after I piss.

Even though I'm married and I've got work and kids, I
can't stop looking at butt. I can't stop looking at derriere.
I can't stop looking at tush. I can't stop looking at rump
roast. Baby, I'm an ass man.

Once I spotted her in the subway: short, Hispanic,

I'm an ass man

BUTT
RUMPROAST
FANNY
TUSH

Polish, Chinese, Irish or Jewish, with a huge butt just waiting to be fucked, just asking to be fucked. She was short-waisted and all I wanted to do was get her against that cold, slimy, rat turd wall and get my cock inside her. She's wearing those four inch cork wedgies that went out of style in the early '70s. And she's wearing those polyester pants and I can see her panty lines through her slacks. She's so fat that the cellulite bunches between her thighs as she walks. I can smell between those thighs, that sweat. Mmm. I can hear the sound of her fat thighs rubbing as she moves. Swoosh, mama, swoosh!

All I want to do is get my mitts against the small of her back. I want to get myself inside her. But first I wanted to feel some of that butt action, that cheek action. Feel some of that butt pressure.

I crack open the seat of her pants, just listening to the fabric tear. I love the sound of ripping polyester. I love the smell of ass in open air. Then I get my fist, my hand, and I push myself up into her ass. I'm feeling the butt pressure on my arm, on my wrist, it's feeling good. I'm feeling her up. It's turning me on. It's turning me on. I can hear that sound. I'm feeling her up. I reach up to her pussy, feeling that fat little mound, that little bird's nest. I keep my hand in there and then, just when I'm ready to mount her, I take my hand out. I see my arm, my hand, and I see that THE WOMAN HAS HER PERIOD.

How could you do this to me, woman? How could you do this to me? How could you be on the rag on me! I'D BE THE BEST FUCK IN YOUR LIFE! THE BEST PIECE OF COCK IN YOUR LIFE, GIRL! THE BEST RAPE IN YOUR LIFE!

And I was running. I'm running. I'm trying to get those purple hearts off my hands, out of my cuticles, but the blood won't come out of my lifeline, out of my heart line, the blood won't wash off my hands. Be a long time before I use that hand to shake my dick after I piss.

THREE WOMEN

Stories from Beyond the Childbearing Years
(There is No Place Like the Nursing Home)

And as I was washing myself my pussy peeled off. That's right, my puss just peeled right off. I went to my husband and I showed him my remains. This is it. This is all that is left. And he said, "Oh, that's what pimentos are. Just put the peeled pussy in a sealed jar and sell it for some extra cash."

Hank and I went into the nursing home on Christmas Eve, the same way we do every year. There we saw an old, leftover, albino crone sitting in her wheelchair, sitting in her pee-soaked, pee-stained dress. We walked right past her until Hank got a whiff of her pee. Hank likes pee smellin' things. Pee turns him on. Hank loves to hang out on sidewalks and building corners smelling piss from

drunks. But old lady pee is something special, like strong brewed tea—medicinal.

Hank picked up the piss granny by her ankles and turned her upside down. We laughed 'cause she still felt modest about us seeing her naked, gray birch thighs. She had some shaking disease, and it was funny seeing her head bob up and down like a chicken with its head cut off. We reached into her brassiere, tore it off, and found a rosary made of semiprecious stones, Kleenex that had collected fluids for a week, and a picture of her son, who had fought in the War of Wars and never returned.

Her breasts were sucked dry. Shriveled, deflated fruits. We were still holding on to her ankles, letting her swing like a pendulum with her urine-starched hospital gown stuck to her hide. We peeled off her undergarments till her skin waxed. She was like a baked tortoise shell that we'd light firecrackers under as kids. Her pussy was navy bean blue and whale gray. This pussy smelled like the sea, so I put my ear up to her cave to hear the ocean roar.

We looked into her oyster, we dug into her clam. I reached for her hysteria, she was an open dam. Then, while looking into her hole, while feeling her up we saw the universe, we saw the meaning of life. We had a religious experience by just looking up this old broad's cunt! We saw history, understood inner truths, felt visions. I saw children dead and buried. I saw babies never born and ones waiting to be conceived. Husbands loved and forever gone. Wars won and lost. Famines, depressions, peace times. Galaxies of stars, dreams, potentials, trials and tribulations.

The old woman began to cry. She wasn't crying 'cause we abused her. Oh, no. She was crying 'cause she hadn't been touched since 1936.

We dropped her on the linoleum for we saw what we were looking for: an old ebony hag. She was an old tree.

A piece of ebony. Knotted. Unruly. Bent. Warts covered her body. An ancient ballerina in toad skin.

We pushed the black granny onto the floor like we were unfolding a twenty-dollar bill. Money has its own smell and she kind of smelled like that. Green. The smell of green.

We took out our single-edged razor blades and sat on her. Very, very gently, very, very slowly, we scraped the warts off of her body. We scraped the warts to collect the wart powder. We collected enough wart powder till we had a sand castle in the hollow of our palms. We spat onto the pile—olive ash—till we had a wart powder paste. We undid our pants and took out the parts that made us men. We smeared the wart grease on our cocks and balls, our genitalia covered in mud. We did it just like our grandmother told us to do. For our own grandmother told us the lore: if you scrape the warts off an old hag that was born in slavery, make a paste, and put it on your cock and balls, it'll make you hard for a fortnight.

Then we went up to 4 South in the nursing home and raped the nurses all night long. All kinds of nurses—blondes, brunettes, redheads, all different colors—just as long as they had holes. We stopped midday on Christmas to go to mass and then have Christmas dinner with our families, our loved ones. Our wives, daughters and mothers prepared savory sauces, puddings and sweetmeats for us. Presents were exchanged.

We were proud to be white men. Carrying on the traditions of our fathers and forefathers—lynchings, beatings, rapes. Our fathers killed the Indians, stole their land, too. Believed in slavery, persecuted and oppressed the Black man and woman. Believed women were only good for raping.

It was going to be a good year that year. We cheered. We toasted. Good will toward men. Peace to all. Noel. Noel.

The Woman's Brain as a Source of Inspiration

Honey, darling, you said as we kissed the invisible past. It wasn't our hearts that met; it was only our souls. Is that why you won't touch my pussy?

The old woman had tumors emerging from the right side of her brain. Huge sores protruding, just popping right out of her head. She was lying there in bed, in the hospital, in all her glory, screaming, asking God to please finally let her die. But God forgot about her. She was lying there ready to die. But God just forgot about her. People just forgot about her. She had other sins, other penances, but the saddest thing is that no one ever loved her. No one ever loved her. That's what I'm saying. She was never loved. So the woman sits with her tumors, waiting to die.

Wise men from faraway ancient cultures and lands, the Vikings, the Hawaiians, the Celts, the beautiful Balinese, came down and visited the granny to see the condition for themselves. You see, it had been known for some time, believed in wise circles and passed on from one wise man to another, that if you drink the juice, the clear liquid, from a granny's brain tumor it makes your semen taste like honey. So, on Friday mornings when I bring the old woman white orchids, there are many wise men, doctors and attending physicians, drinking the tumor juice from long straws while nurses are on their knees sucking the learned men's cocks.

"It makes their semen taste like honey, dear," she whispers to me. "It makes it taste like honey."

You"ll Never Know Your Grandchildren
Till They Take Care of You

When I get my husband his cheesesteak sandwich, just the way he likes it, he turns me over in the kitchen and he gives it to me in the ass. He says that's the way you deserve it, baby. That's the way I like it.

So when things get real bad, real bad, dad, dad, I take a can of yams and I stick it up my granny's ass. She's such a fine granny to humiliate, she's such a fine granny to torture because she's a mute granny. She's my granny. Doesn't make a sound. Her eyes bug out like blue eyes on a rabbit, like some furry little animal.

I smear her all over with the candied, sugared yams. I turn her over on her back so the candied syrup sugar yam juice runs down her back along her spine. I laugh 'cause I never seen my granny this way.

Then I put her under a heat lamp and I let the yam syrup sizzle on her spine; it boils real nice. She's such a nice granny to torture. She doesn't make a sound. She's so fine to do it to. Then I put a tab of ecstasy in her cup of Nescafe every morning and she just looks out and hallucinates all over me. Hallucinates all over me.

SLEEP OVER

Love Thy Neighbor

One of my children limps, one crawls, and another stutters, but I still want a daughter. Maybe she could have other opportunities besides biological opportunities.

I was so happy when the Hirsch's moved next door. They had a daughter my age and soon I was participating in all their family activities—camping, canoeing, swimming, fishing, baseball. And once I spent the night there. I was washing my hands in the middle of the night after I awoke to pee. Mr. Hirsch came into the bathroom while I was in there. He was wearing his pajamas and his poker was sticking straight out of his bottoms.

And I asked Mr. Hirsch, "What's wrong, Mr. Hirsch?"

And he said "Oh, I don't feel well. My pee is stuck in my wiener. I'd wake up Mrs. Hirsch or my daughter but their mouths are weak with sleep. And I need my pee sucked out of my penis now or it's going to backtrack into me and I'm going to die."

I said, "My own daddy never had me do this. Can't I call my daddy and ask if I should do this?"

"No, there isn't time. There isn't time," he said. "You don't want me to die, do you? You don't want to be responsible for my death, do you?"

I didn't trust Mr. Hirsch, but I still didn't want him to die. I also didn't want to go to jail.

"All right, Mr. Hirsch, I'll suck your penis for you. But first, you have to stop calling me 'Yo.' And you've got to take those gold chains, that peace sign and license plate that says 'Sylvester Moses' off your hairy chest, and you got to drop that ghetto blaster too."

So my head is slammed tight against the toilet bowl and I'm smelling the cat pan. Get that cat pan away from me! Get that cat pan away from me! I'm smelling last month's flu and Mrs. Hirsch's dropped perfume. Get it away from me. Get it away from me! But no one can hear me because my throat is full of him. And he's saying, "Pretend it's an ice cream cone, pretend it's an ice cream cone."

I can't breathe. My throat hurts. I'm going to die for sure. Stop! Stop! Then I found out that boys' pee tastes different from girls' pee. Boys' pee tastes different from girls' pee.

"Modern Prayers

MODERN PRAYERS

MOTHERS AT THE GRAVES

When Mama killed herself she lay there for weeks before anyone found her. In the back of my mind I thought that maybe it was murder and not suicide. I try to glamorize the story by calling her a poet when really she was just another sick motherfucker.

All of my family is crazy. My mother was crazy. Mental illness runs in my family. Alcoholism runs in my family. Addiction is a talent for my family. The only way to survive is to make fun of yourself. The only way to survive is to move to New York City. The only way to survive is to display your damaged goods. I'm a pervert. I'm insane. I'm no good. I'm sick. I'm ugly. I'm retarded. And I'm alive.

Every time I wake up I wonder if I'm sick. Everytime I go to sleep I wonder if it's my last night on Earth.

The family was rich and famous. The family had books, beauty and brains, but it didn't have kindness. It didn't have charity or gentleness. This family believed

that you've got to work for it. You've got to pay your dues. You've got to suffer. I hate that shit! I hate that fucking crap! I hate people who think that you can think problems away. I hate people who think that you can think AIDS away. I hate people who believe you can good-clean-lifestyle AIDS away.

My mother gave me enemas at night. She used to slap me around. She spanked me and hit me. She can't help it, she's drinking, she's sick. Quiet, quiet, ssh. Don't let your mama know you're awake.

My father beat me everyday. He beat me everyday till I felt nothing. I've never had anyone who could beat me like my father. So I've become like my father. I've become that bum, that geek.

My mama keeps me down. My country keeps me down. I stopped trying. I just started to believe I couldn't make it.

My city got more and more corrupt. It became harder and harder to breathe. One day I just stopped breathing. I walk around but I'm dead. No one cares about me.

My country doesn't care for my type. I'm an instigator, a truth-sayer, a troublemaker. I just stopped breathing one day.

When I had a baby and it cried I killed it. I hate noise. I hate something out of control. I want a perfect baby. I want a perfect life. I didn't like the baby so I killed her. Slowly, in the water, I drowned her. Everyone kills in this world.

I saw the bodies fall from the Kuwait airliner while newscasters spoke in a monotone. It's not a perfect world.

I see Israeli's assassinate PLO leaders.

I see Bernie Goetz go free.

I see Robert Chambers get away with murder.

"So I'll kill my baby for me," said the mother in her empty room on Mother's Day.

And mothers cry at the wailing wall called the Vietnam Memorial. Mothers cry at windows holding picture albums of sons lost to modern plague. Mothers walk to their children's graves asking, "What happened to this country?"

"Why did my son die?"

"Let me see a sign."

"What are we going to do?"

We're not going to sit and cry, Mama, and let others continue to die. We're going to protest. We're going to inform. We're going to riot, terrorize, petition, organize and demonstrate.

"I'm tired of doing AIDS benefits," she said. "My friends are still dying."

Listen lady, listen mister, who said it was going to be easy? Who said it was only going to take ten benefits, a hundred benefits, a thousand benefits, ten thousand benefits? Do you think that it took only one civil rights march, one antiwar demonstration, one burning bra? We're still fighting for civil rights. We're still fighting for peace. We're still fighting for equal rights for women. And we'll fight for an end to AIDS. We'll fight till there's a cure for AIDS.

I call upon the spirits and souls of plague to come down to us and refresh our hearts and minds with energy. We'll march again. We'll protest again. We'll benefit all night long.

DROUGHT

One day it just stopped raining
The sky couldn't cry anymore
The sky wanted to stop crying
and start doing something
This was the only way to get people's attention.

One day it stopped raining tears
but rained blood
It rained blood and garbage and shit
No one knew where it came from
This was the only way to get people's attention
The blood and shit landed on beaches
This was the only way to get people's attention.

One day all the fish decided to die
One day all the birds decided not to fly
All the vegetables stopped growing.

One day all the air left earth
It wasn't worth giving life to us anymore
This was the only way to get people's attention.

One day Gloria's son killed himself
Sometimes you have to do extreme things to feel loved
to feel missed, to have your love accepted
I've spent most of my life trying to convince others that
I love them
but they've never accepted my love.

I'm waiting for the right time, he says
(everyone knows it's always the wrong time)
Don't wait
for someone who once left you
to return to your doorstep
for a divorce to be final
for the right person to come around
Don't wait till I'm eligible
till I get a loft
till I get a John
till I get a job
till I stop being sick.

I've spent most of my life trying to convince others that
I love them
but they never accepted my love.

My country hates me
My city wants to get rid of me
My family disowned me
My husband left me
My babies were never born.

Sometimes I get so angry here in the summer. Every year I say I'm not staying in New York City. I have dreams of going out and beating to death all of the flowers in my family's backyard. I dream of destroying swimming pools and air conditioners. I dream of decapitating roses and sunflowers and daylilies. I recall my first violent act—killing a tiger-tail butterfly. I captured the stained glass critter and suffocated her with rubbing alcohol. We love to kill beautiful things. We live in a world that loves to kill beautiful things.

Tonight, let me remind you of July nights, of dancing fireflies, the sounds of crickets, a blanket of cool pine needles, slurpies, red ball jets and hot panting dogs. And as soon as we were eighteen we got the hell out of there.

Whenever I visit the suburbs I break out in a sweat hotter than Avenue D and 3rd Street. Whenever I visit nice, secure folks' backyards and sit on their lawn furniture I break out in a sweat hotter than the F train at the 2nd Avenue stop because I knew from the beginning that I don't belong to the family class, the middle class, the upper class. I feel uncomfortable around windows that aren't barred up. I'm a caged bird in heat.

I'll tell you why I only feel comfortable around the collapsed, the inebriated and the broken—because they look like what I feel inside.
They look like what I feel inside.
They look like what I feel inside.

Last night I dreamt of beating marigolds to death, strangling petunias and decapitating pansies, daylilies and snapdragons. They didn't cry, they just stopped growing. I was surrounded by bleeding naked necks of flowers, stems and stalks, black and blue petals; and the petals blow through the smells of the city.

And I wake up and I'm back home in my artist ghetto. It's the only place where I belong. A place where flowers haven't grown for a long time. Where rainbows haven't been seen for a long time. Where trees don't get paid to provide shade.

Yeah, it's summer, call it sunshine. And I try to smile and I try not to smell all the shit on the streets and see the needles in the arms. I try to say, "Oh, the homeless are only burning and at least they're not freezing." It's just another corner in hell.

IT'S ONLY ART

I went into a museum but they had taken down all the art. Only the empty frames were left. Pieces of masking tape were up with the names of the paintings and the artists stating why they were removed. The guards had nothing to guard. The white walls yellowed. Toilets were locked up in museums because people might think someone peeing is art. Someone might think that pee flushing down that toilet is art. Someone might think that the act of peeing is a work of art. And the government pays for that pee flushing down that toilet. There were many bladder infections among those who inspected the museum making sure that there was no offensive art. They might lose their jobs. It's a good life when no one thinks that you ever piss or shit.

In the empty frames were the reasons why art was confiscated.

Jasper Johns—for desecrating the flag.

Michelangelo—for being a homosexual.

Mary Cassatt—for painting nude children.

Van Gogh—for contributing to psychedelia.

Georgia O'Keefe—for painting cow skulls (the dairy industry complained).

Picasso—for urinating, apparently, on his sculptures, with the help of his children, to achieve the desired patina effect.

Edward Hopper—for repressed lust.

Jeff Koons—for offending Michael Jackson.

All ceramicists were banned because working with clay was too much like playing with your own shit.

All glassblowing became extinct because it was too much like giving a blow job.

All art from cultures that didn't believe in one male god was banned for being blasphemous.

We looked for the show of early American quilts, but it had been taken down. One guard said that a period stain was found on one, another guard said he found an ejaculation stain on a quilt from Virginia. In fact, they closed all of the original thirteen states. You can imagine what happened under those quilts at night!

Since the Confiscation of Art occurred, an Art Propaganda Army was started by the government. Last month the national assignment for the army artists was to make Dan Quayle look smart. The assignment for the army writers was to make the stealth bomber as important as the microwave oven. Musicians were asked to write a tune, how the HUD scandal was no big deal, like taking sugar packets from a cafe. Dancers were to choreograph a dance showing that the Iran-Contra affair was as harmless as your dog going into your neighbors yard. And filmmakers were told to make

films about homelessness, poverty and AIDS, saying that God has a plan for us all.

But no art came out.

No art was made.

Newspapers became thin and disappeared because there was no more criticism. There was nothing to gossip about. Schools closed because learning got in the way of patriotism. No one could experiment, for that was the way of the devil.

There was no theory. No academia. No debate teams. No "Jeopardy."

Everyone became old overnight. There was no more reasons for anything. Everything became old and gray. Everyone had blue-gray skin like the color of bones, unfriendly seas and navy bean soup. And then the Punishers, the Executioners, the Judges of creativity grew weary, for there was no creativity left to condemn. So they snorted and they squawked, but they held in their boredom. All that was printed in newspapers, journals and magazines was the phrase, "I don't know."

All actresses and actors were gone from TV except Charlton Heston. Charlton did TV shows twenty-four hours a day (with occasional cameo appearances by Anita Bryant).

One day Jesse Helms was having some guests over from Europe. A dignitary, a land developer and a king. Mrs. Helms asked them where they'd like to go in America. The king said, "Disneyland."

Mr. Helms said, "Oh, that was closed down when we saw Disney's film *Fantasia.*"

So the guests said, "Nathan's Hot Dogs on Coney Island."

Mr. Helms answered, "Sorry, but hot dogs are too

It's Only Art

phallic. In this country we don't eat anything that's longer than it's wide. Nathan's is history. In this country we don't even eat spaghetti. Bananas aren't imported. Tampon instructions are not allowed."

"Well," the guests said. "We'd like to go to the Museum of Modern Art, and if we can't go there, then why come to America?"

Mr. Helms was stuck. He wanted everyone to think he was cool, having Europeans visit him. Then he had an idea. He'd make the art himself to put back into the empty museums. He'd get George Bush and William Buckley and Donald Wildmon and Dana Rohrabacher and Tipper Gore and other conservative allies to come over and make some art on the White House lawn. So he called all of his cronies to come on down and make some art. And everyone came because it was better than watching Charlton Heston on TV.

Mr. and Mrs. Helms looked all over for art supplies. They came up with old wallpaper, scissors and house paint, and laid it all out for their friends to express themselves.

When the friends arrived they were scared to make art because they never had before. Never even used a crayon. But then a child picked up a crayon and drew a picture of her cat having babies. Then she drew a picture of her father hitting her. Then a picture of her alone and bruised. The mother looked at the picture and cried and told the daughter she didn't know that had happened to her. The child screamed out: "DRAW YOUR DREAMS! DRAW YOUR NIGHTMARES! DRAW YOUR FEARS! DRAW YOUR REALITIES!"

Everyone started making pictures of houses on fire, of monsters and trees becoming penises, pictures of making love with someone of the same sex, of being

73

naked on street corners, of pain and dirty words and things you never admitted in real life.

For thirteen days and nights everyone drew and drew nonstop. Some started telling stories, writing poems. Neighbors saw the art-making and joined in. Somehow, pretend was back in. Somehow, expression sprung up from nowhere.

But then the Confiscation Police arrived and they took everyone away. (The father of the child who drew the father hitting the child complained.) Everyone was arrested. They even arrested Jesse Helms, for he was painting his soul out, which was HATE AND ENVY AND CRIME AND DARKNESS AND PAIN. They threw him into the slammer. He was tried for treason and lost. And on his day of execution his last words were: "It was only art."

HAPPY BIRTHDAY

I have never really understood the ritual of a woman hopping out of a birthday cake. It's always been a favorite stand-by plot for a TV sitcom, where usually the male lead has or throws a party that only men are invited to, and then a woman jumps out of a cake, partially clad, and all the men become thrilled and happy. On TV we never see what happens next because the wife or girlfriend discovers the party, feels hurt, jealous and disgusted, and sets out to end the party. But in real life we know what really happens next. The solitary woman is desired simultaneously by all the men. A potential celebrated gang rape. What a theme for a party! It has been the underlying theme for stag parties for generations.

Why is there only one woman in that cake? Or just a few women invited to a stag party? Because if there were a woman for every man it would be too demanding for them, defeating the idea of the party. The men would be selected by the women; they would have to

OUT OF THE CAKE
TRICK —

talk to them. This would take away from the male bonding party experience.

There are many reasons why women do not have a man jump out of a cake at showers or girl-talk parties. The main reason is simple biology: one man could never satisfy all the women at the party. His prostate, his wiener, just couldn't do it. His tongue would fall off if he'd attempt to give all the girls hours of multiple orgasms. You can see why women don't even try. Satisfying twenty women takes a lot longer than satisfying twenty men.

In order to balance the scales, here are some suggested party rituals for women to use for showers, graduations or promotions:

TAKE OUT THE GARBAGE GAME: Give a guy a couple hundred bucks to take out your garbage. Make sure the guy is cute in a soap opera kind of way. Invite your girlfiends. Have a barbeque in the yard. Have every guest bring a month's worth of garbage. Just as your guests are drinking and eating in the yard, have the cute guy start bringing out bags of garbage, one at a time. With every bag of garbage he takes out, he takes off a piece of clothing. He takes out garbage until he's real sweaty and exhausted and naked. Invite your guests to surround the cute dude, point their fingers at his penis and laugh. Shake cans of beer and spray them on the cute dude. Slap your thighs a lot and just keep on saying, "This is a great party!"

THE ROTO-ROOTER GAME: Go to your local hardware store and tell a guy you'll give him a couple hundred bucks to unclog your drain if he does it naked. Invite fifty girls to a party to drink champagne and watch him

unclog the kitchen drain. Take bets before he arrives on the size of his penis or how many hairs are on his balls. Hide his clothes and just drink merrily. Touch your own tits and clit while the guy is running around the house looking for his clothes. All guests will bark like a dog when he's on all fours looking for his clothes. The birthday girl gets to tell the man that the doctors are going to do a roto-rooter job on his plumbing when he gets older and his prostate swells. Then the birthday girl does what she wants with him while the other women watch. The other girls don't care, though, for they'll have their turn on their birthdays and it's all in the name of fun anyway.

THE OLD GUY GAG: Ask an older man who only likes to go out with real young chicks to come over to meet your Miss Teenage USA sister. At the party have a young girl undress him. Just when he gets excited, lock him in a room and force him to watch films about prostate cancer. Have everyone take turns sitting on his face—and he'll do anything just as long as they stop those tapes about infected prostates. Put him in a cake. Have him shake his old thing to Henry Mancini. Have a drum roll. Sing Happy Birthday, Happy Anniversary.

I hope one day we can celebrate with humanity and not with humiliation.

SUMMER VACATION

Seeing people enjoy themselves has always made me nauseous.

New Yorkers either complain about being in New York in the summer or they leave, and tourists are too glad to replace them. Last week I spotted tourists in Bloomingdale's videotaping their purchases at the make-up counter. How stupid and boring can you be? Doesn't anyone have a memory anymore?

I don't document every emotional event in my life because then I couldn't lie about it later. Videotape documentation destroys legends, thereby destroying myth.

I'd never videotape the birth of a child. Have you ever been at someone's house and had to sit through the bloody mess? I don't want to see your child's first shit, just like I didn't need to see a graphic illustration of Reagan's colon cancer. I was relieved to see that Nancy Reagan had breast cancer. I didn't think she had breasts at all.

Staying in New York in the summer means trying to get out of having people stay in your home. Most out-of-towners don't understand this; since their lives are so quiet and boring, they love for you to stay with them. It's just that on the streets in the city you're sharing and relating all the time, so you don't want to be sharing in your own home. Besides, too many New York apartments are roach-infested and in crack neighborhoods—holes-in-the-wall that we call home and work our fucking asses off to keep. But the first thing your guests will say is: "How can you live like this?" And they're taking their fucking vacation in your $1000-a-month room.

Please go back to Ohio now!

Your guests will never understand why you don't go regularly to museums, Broadway shows, the ocean, or have never been to the Statue of Liberty.

You can always spot tourists by the way they attempt to wear black. In a feeble attempt to look cool, they wear clothes with shoulder pads which they bought at a one-stop-shop or at J.C. Penny's. They usually round up some headgear for the New York trip and some loud jewelry that they are proud of and insisted on buying for you, too.

Another nauseating problem with guests is inviting them to meet your friends. You know, friends who have never been to your apartment even though they are your dear friends. Your out-of-town guests will never understand why you don't want anyone over, nor why you don't want to go to anyone else's apartment. (Then you'd be obligated to reciprocate.) Friendship is best kept in public places.

Your guests will try to help you out by giving a party in your honor in your home, with brie, California chablis, and Tex-Mex burnt meat on sticks. At the

party your guests will start asking your friends to explain acid house music and who Tama Janowitz is. You look at their happy faces and their St. Mark's Place T-shirts, and plan to rip them off their bodies while they're asleep, wipe the rim of your toilet bowl with them, and get happy when they wear them while drinking California blend coffee in clear glasses.

New Yorkers on vacation are easy to spot because they are always the people who are not enjoying themselves, or are complaining and making a scene. They never wake till dark. They always look uncomfortable in relaxed, pool fashion, as if the no-pressure situation was cause for an impending nervous breakdown. Remarks like, "It's better in New York," always help to make their vacation more hostile and negative. By the end of the stay, New Yorkers on vacation have plenty of scapegoats and great things to make fun of.

It's 2:30 AM and we're out in the woods, in nature, screaming, "This is why I live in New York City!"

Last year when we met my family in northern Wisconsin, we walked around saying, "It's so quiet," and, "It's so cheap here." (Tourists walk around New York saying, "There are so many people. It's so smelly. It's so expensive.")

On my vacation in Wisconsin we were looking for cheese postcards and sweatshirts that read, "Muskie Capital of the World." At night we listened to stories of family accidents, like when the hot iron fell on my mom's thigh, how my brother fell down the stairs through the china cabinet, and when my sister put a pearl up her nose. This history has no video verification.

On vacation, we try to get as bored as possible so we have a reason to return to New York. Your guests, on the other hand, are becoming so overly stimulated that they're being devoured by New York. Now your guests can actually get into clubs without you, and they have had sex with people you know. They have gotten as bitchy as possible so they have a reason to return home to the average American lifestyle of convenience. Comments like, "I can't wait to drive my car" are a sure bet that they are packing their bags.

But before your guests leave, remember to get as many free dinners, taxi rides, and drinks as possible. And never say, "This one's on us."

BACK TO NATURE

Recently, when I was driving on the Henry
Hudson Parkway, a Jaguar stopped amidst traffic so its
driver, clad in Armani, could relieve himself. He was
quite indifferent to us catching glimpses of his pee
spraying in the wind. This is a very common occur-
rence—answering nature's call outdoors—yet it is
extremely rare for a woman to relieve herself in such a
manner. One might argue that it's man's physical
structure that enables him to whip it out and pee
naturally outdoors without the prison structure of a
urinal, and that peeing outdoors against a car or
building is quite fulfilling. Yet I believe it's about man's
rite of displaying territory, in the same manner that
dogs mark out their territory.

It's quite interesting that in our thinking society, with
our sophisticated sensibilities, the idea of holding it in
is unthinkable to the male. One reason why women
must hold in their pee is because if a woman just peed
in the street she would be thought of as sexually

deviant and would be subject to sexual violence. In the same way, men can go topless for comfort, but if a woman does it, she immediately becomes sexualized, desired and judged.

There are favorite pee haunts in every neighborhood, a designation that is established collectively and un-consciously. I'm sure you know where peers pee on your block. It's usually against something, giving the illusion that they're invisible (dogs and cats try unsuc-cessfully to bury their shit in a similiar ritual).

I propose that women get back to nature by peeing in public as well. Wear a long wide skirt without under-wear, spread your legs, let it flow, and walk away. Pee in all art museums that do not equally represent women and minorities. Pee in all polling booths that only have white males on the ticket, and pee on all classic rock stations that only play white male groups. Then, when women finally gain pee public rights, we can have massive pee-ins on the White House lawn.

But I'll tell you, I'd never want to have co-ed toilets (even with urinals), 'cause you guys never aim.

ACCESS TO FASHION

Men's clothes need to be eroticized. That's right,
men's clothes need to be eroticized. For years fashion
has dictated that businessmen wear suits with penis
symbols around their necks and down their chests. It
would be uncanny if women wore vulva symbols
around their waists, or an extra set of breasts for knee
pads on slacks.

Men should learn from women how to reveal and hide
their bodies with fashion. Men need to have their
nipples more eroticized in everyday, at-the-office
clothing, like little see-through panels across their
chests, revealing tinted and designed hairs in the
tradition of fake eyelashes, i.e. nipple lashes.

There should be special colors, fabrics and collars for
men's equipment. They should grab attention to men's
scrotums. Testicles dressed with nice, woolly caps to
emphasize the hairy-ball look. Gaudy, high-heeled
oxfords, deck shoes and Nikes to make their butts go
up in the air so we can all fantasize grabbing them

from behind and reaching in between their legs for a quick goose.

Most fun of all would be fabricated erections in men's fashions. Banana and salami images stuffed and appliqued right on a man's crotch. And jewelry for the fly—bold topaz and diamond-studded zippers, zippers of netting, of silk and brocade. In the same way that women's clothes have mandatory shoulder pads, giving the wearer (and the public) the feeling of access to big-shoulder male power, men's fashions should include falsies to give the wearer the illusion of nurturing and access to feminine instinct.

ST. PATRICK'S TRUTH

I really don't like St. Patrick, I never did. I don't like St. Patrick for driving Paganism out of Ireland, for getting rid of Pagans. I love Pagans. I'm a devout Pagan. Paganism—when goddesses were equal with gods, when god wasn't only in the image of man. What St. Patricks Day is really about is getting fucked up.

"All I want is an Irish, red-headed grandmother. I want a hot, thick waisted, tits-down-to-her-knees granny. I want an Irish red-headed granny with a hot used up pussy," said the Prince of Wales to the Queen Mother on his birthday.

"Continue," said the Queen.

"I want an Irish Catholic granny whose country we've controlled for centuries, whose culture we've repressed, whose women and property we've pillaged. No wonder they have a repressed religion, but guilt turns me on. Guilt turns me on. Queen, I want my granny's saggy tits in my face. I want to lick the bourbon out of her

pussy. I want her to piss on me. But she only likes her sex the Irish birth control way, in her ass. I soap up her granny ass with Irish Spring soap.

I want to fuck your Irish granny ass and pass you around the members of Parliament and remember when thousands of Irish children were made slaves by the British empire in the 1700s. Irish were denied university education to be made lazy lying ignorant drunks. They were better to fuck with that way. Their culture, their language were completely taken away from them. Left only with celibate priests.

I'm in County Cork
I'm in County Mayo
I'm in the Bogs
I can hear the potato famine cries
All farms owned by English Protestants
But I'm fucking the Irish granny.

Let me tell you how I was almost raped in Killkenny. We drank a lot of whiskey after supper, and my sister-in-law Betty, her husband Sean, my cousin Jerry, and I, we went to the Caverns. An electric storm occurred. All the lights went out. Sean tried to force himself on me in the henhouse but I grabbed his testicles. He tried to rape us in the bedroom but he couldn't get it up. I didn't know that Robert Chambers had relatives in Killkenny.

Hush, child. Robert Chambers has relatives everywhere.

When I told the women folk what happened to us, they told us we flirted when we passed the butter and potatoes, that our attacker just wanted to give us more blankets. We were run out of town.

Like they say in Kilarney—
The men live long lives and the women never die.
Or as they say in Tipperary—
Many a mickle makes a muckle.
Or as they say in Giants Causeway—
I'd know his skin on a bush.
And as the nuns say—
All women should wash while their clothes are on. It's a
sin seeing your own naked body.

Whatever happened to Bernadette Devlin?

The bottle's out again
They're drinking senseless again
Why'd they have me?
The leather strap is on my behind, on my behind again
Whipping mc good
Obeying like I should
I love my parents
I don't mind
I'm all alone in the dark
I hear the fights all night.
At eight she was molested by her brother
At ten she was fingered by her brother
At twelve she was beaten senseless by her mommy
At fourteen her babies were sold in the autumn
Made by her daddy's cum.
They said it was love not rape
It was incest in any case
Hush, now, hush.
Oh, the bottle's out again
It's St. Paddy's day everyday
Drinking senseless again.

Why'd they have me?
Why did they have me?
I only love men who hate me
I only hate men I love
To me it's better than nothing at all
Nothing at all
Nothing at all
I can't really blame my daddy
His daddy molested him too
 and his daddy's mommy
 and his mommy's mommy
 did it too
Generation after generation the story continues
Hush, now, hush

When you tell me you love me I get angry
I don't know how to be loved
I only know how to be abused.

I want to believe in fairies
The twinkle, the mystic
The shamrock spirit
I want to believe in the invisible
But there are no feelings in this computer thinking
world
So, I drink myself into a stupor
So, I don't feel anything at all
'Cause the only feelings I feel are no feelings at all
The Protestants condemn the Catholics
The Pope condemns the rights of homosexuals
The English have a history of making the Irish their
slaves
And the Irish Americans have a history of making
Africans their slaves.

You have a good job for a woman.
You're not flighty, hysterical or emotional.
What's for dinner?

Fishsticks, Egg McMuffins, Burger King. Anything you
want fatso!

Shut up! The only reason I like you is because you're
sterile. You're dad fucked you with a coke bottle and it
broke inside of you. I like women who are damaged
goods.
You can depend on 'em. I love an angry woman. I'm
gonna fuck you right now unless you shut up!

In front of the kids?

They're invisible. I only had 'em to give something my
last name. I couldn't paint so I had kids.

But I birthed 'em,

My father is in hell
My mother is a living hell
And I'm hell on wheels.
No, you're not, you're not exciting like hell.
You only know how to express yourself through meet-
ing the needs of others.

Until recent times the storyteller was arrested for
promoting Irish history.
Words are something you can't buy
Language has no boundaries
Words can kill with no blood
Words inspire change, overthrow

Overthrow governments and systems
That's why they try to censor us.

Why don't you ever leave the house?
I'm afraid of pinecone air, children's voices and bells
I'm afraid of dollies, pastels and red curly hair
for they remind me of the fairies, the leprechauns
The pot of gold at the end of the rainbow
Been a long time since I've seen that rainbow in
America
Been a long time since I've seen a rainbow patch on a
jean jacket
for I live the life of a corpse
The non-feeling concrete slab
For I live in the town called APATHY
I live on the street called OVERLOOKED
I live in the state called REAL ESTATE
I live in a land called GREED
My pot of gold is my pot of piss in the morning
I'm afraid of change and choking
Being alone with the devil
I'm afraid of white men
I'm afraid of all governments
I'm afraid of ignorant politicians
I'm afraid of censorship.

This teardrop is from the sea of sorrows
This hand of sand is from the great Valley of the Kings
This glimpse of darkness is just a small part of the
night
I dreamt the whole world laughed together at the same
moment
I dreamt the whole world said it was sorry to each other
and to Mother Earth
When everyone laughed it was like a huge sneeze

There were no more mean deeds
No more bad thoughts
Diseases were shaken out of bodies
Everyone was laughing so hard.

Suddenly, I began to cry. I wanted bodies around me.
Laura had a hysterectomy. Carla had fibroid tumors
and Maria had cervical cancer.
I became fearful of becoming sick. I couldn't stand it so
I slashed my wrists.

But I don't bleed
I don't bleed
I don't bleed
I forgot I couldn't die
For I had never lived.

It was St. Patrick's Day and I wanted to be a pagan
I wanted ritual and magic
I wanted to see dancing
I wanted to hear Gaelic chanting
I needed to see green and gold charms shake on naked
flesh
I needed to hear other music besides pop classics
I needed other smells besides fast foods
I needed new answers besides Christian-Judeo bullshit
I wanted the deception of the veil instead of the
obviousness of fashion
With the veil the ugly have a chance
Eyes speak without lips
I couldn't compete anymore
But I'm in the race anyway.

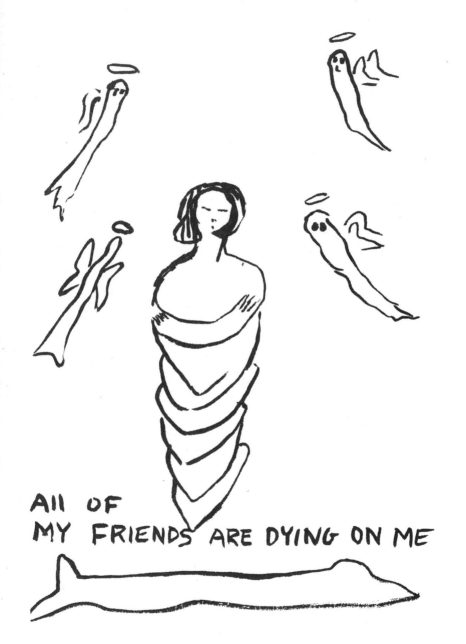

PARIS WITH JOHNNY

I always thought that when I got to Paris
Johnny would be there to welcome me.
I thought this as we entered the city by car.
The trip suddenly felt lonely without his presence.
From the European auto the French
excitement depressed me.
All I wanted was my Johnny-friend back.
A shrill of electricity went up my spine.
A pale green and blue hue was
on my right shoulder.

Outside, an old man walked in front of our moving car.
His head landed on the pavement. I saw his head,
under the car, at the wheel, there was no time to stop
from running over an old Parisian man by some stupid
American artists who think they know everything.

We got out of the car. The man stood up. The car ran
over him but he was not hurt. The car ran over his
head with the tire track still on his beret. You don't
question luck, happiness and health. You don't ques-
tion an angel in Paris.

When I sat in the car I knew it was Johnny. I could
hear him chuckling. I could hear him speak about the
Pompidou, Marie Antoinette and champagne. It was the
color of cactus, the color of moss, the color of everlast-
ing. And I tried to smell his breath. Then I cried. My
friend had died of modern plague and I felt so guilty.

'Cause I hadn't died with him.
I felt guilty 'cause I wasn't sick.
All of my friends were dying on me.
I hate the people I love now.

I told him I hated his father for not announcing his
death. And Johnny-spirit said,
"How could he? He never announced my life."
And I asked him if he had seen Baby Girl Corey
who had died in the same way?
Had he seen her in the wind?
"No, I've seen her in the stars."

And I told my Johnny-heart how I hated his father
for never accepting his sexual preference.
And Johnny-love just sang:
My spirit is stronger than my flesh.
My soul is larger than my body.
Don't worry, I visit the provider
the punisher
the moneyman.
I am sleepless nights.
I am actors in dreams.
I am conscience.

I SEE YOU CHILD

I see you child dying before me
Not living in a way I wanted.
They told me to let you die peacefully
and quickly.
I agonized and we went to battle.
Distance, time and medication.
Money, cures and prayers.
FAITH

I see you child living before me.
Remission is the word. I shouldn't
have allowed the transfusion. I shouldn't
have gone to that hospital. I shouldn't
have lived in that city.
He shouldn't have been the father.
But then I wouldn't have had you.
HOPE

I see you child giving up.
Please don't give up. Please don't
give up. It's my fault. It's
all my fault. It's my karma,
my sins, my weakness that
came alive in you with your
illness. I make a deal with
God. He's not home.
PRAYER

I see you child growing.
Child is older than me now.
She teaches me many things.
I never knew how to love before.
I never knew how to appreciate
before. There never
was youth in child's body.
That is what I wish I could
give her. One day of no worries
no cares no pain no suffering.
LOVE

I see you child smiling.
And the tears swell up inside
me. How can so much suffering
make so much love? No one
understands us. No one
understands how I can love the
future dead. No grandchildren
for me. No children for her.
No life for her.
I make a deal with devil man.
I have no soul.
CHARITY

I see you child crying.
But she is so weak no sounds
or tears. Pale gasps. The end is
near. I tell child I am her
mother and that when she dies
she must go on the other side.
She can't stay to protect me.
Child wants to stay with me.
Child smells different now.
A wet smell. More
like Autumn than Dawn.
PEACE

I see you child dying.
Her soul leaves the body. But
soul is so young it doesn't know
how to leave the room. I call on
mother spirits to take her from me.
Please don't let her see I'm crying.
Take her to giraffes and violets and lollies.
People in white coats always say it's
like this with mothers. What other
way is there?
ACCEPTANCE

I see you child in a box.
It is obscene. Child is too small
for the box. But it isn't sweet
like boys shaving or girls putting
on lipstick. I am all alone.
There is nothing. This is hell.
All I see is darkness. Baby child
was my child. I loved my
baby child. I was a good
mother. I was a bad mother.
GRIEF

I see you child in the photo.
I made an album to
child. Everything reminds me
of child. Children's laughter
brings tears. Swing sets, rulers,
and kittens bring pain. I count
the days, the weeks from the last
moment on earth. My life is
counting backwards. I sleep
with the clothes of child and
keep all of her toys.
MEMORY

I see you child in the sky.
I know she chose azure and turquoise
for the rainbow.
I am no longer a mother. They tell me.
Go back to your old life. They tell me.
But this life was worth living.
No love stronger.
Your life gave my life meaning.
No life stronger.
I love you child forever.
Forever I will be your mother.
ETERNITY

WE KEEP OUR
VICTIMS READY

WE KEEP OUR VICTIMS READY

I WAS NOT EXPECTED TO BE TALENTED

I have never been out of the county nor have I ever been to New York City even though my husband goes to work there every day. I am a committed waitress and mother, who looks forward to purchasing a new thousand dollar sofa set. Isn't that what working is for?

Last night I cried till dawn. I cried because I want a daughter but instead I have had three sons. I feel if I have a daughter I can give her chances I never had. This is something perhaps only women would understand—that up to this very day, girls, daughters are killed for being just that. Girls. Daughters. Females. No wonder the entire psyche of women is universally coached to be as desirable as possible, as boring as possible, as cute as possible. Obviously, it's for the survival of the female species.

Yes, maybe my daughter could have the chances I never had. Maybe she could get another kind of job

instead of serving, nurturing for pay that most men would never work for. For a waitress there is no pregnancy leave, maternity leave. Bearing a child can mean the end of a career, a woman can be abandoned by society, and the government wants to make it impossible for women to have a fair share along with men. Waitressing, which is shiftwork, doesn't correspond with day-care hours, and a sitter costs more than half a woman's salary. No insurance. No sick leave. No paid vacation. Restaurants are paying below minimum wage. In fact, many upscale hotels and restaurants hire men, not women, to work the dinner shift, which brings as much as three or four times more money. I keep all this to myself because I was not expected to be talented.

I WAS NOT EXPECTED TO BE TALENTED. You see, I was not expected to be talented. That's why I wanted a daughter, who I could encourage, who could lead, who could eventually leave this god damn domestic cycle. But I've been told by the doctors that I could not have anymore children. I worked too hard and long into my pregnancy even though most waitresses stop working when they "show" since most customers find a pregnant woman serving food unappetizing.

Yeah, you tell me I'm supposed to stop thinking about everyone else's problems and start thinking about my own. Well, as soon as I start doing that everyone else's lives collapse and I'm left to pick up the pieces. Just smile, act pretty, open the door, and clean the toilet. You say, "One day at a time." Well, it's a slow death! I'm told to remember those who are less fortunate than myself. Remember the homeless, the poor,

I WAS
NOT EXPECTED
TO BE
TALENTED

the suffering. Well, I'm suffering inside! Anytime I see someone caring or sharing, I burn up inside with envy. You know why I only feel comfortable around the collapsed, the broken, the inebriated, the helpless and the poor—'CAUSE THEY LOOK LIKE WHAT I FEEL INSIDE! They look, they look, they look like what I feel inside!

You see, I WAS NOT EXPECTED TO BE TALENTED.
And when I see you
after you beat me
after you degrade me
and you stand on top of me
in some god-awful museum
you say to me,
There are no great women artists!
There are no great women artists!
There are no great women artists!
We are always the exception.
I was not expected to be talented.

Instead of going to church
I walk past the sites in Central Park
where women have been raped and murdered
And think about the men who just walked away
after they performed their deed
And then I think of this country's heroes
and how they treated their women
Like the Kennedys
how they treated their women
Marilyn Monroe—they killed her, left her for dead.
Mary Jo Koppechne—they killed her, abandoned her like shit.

And I barf when I see William Hurt—
He thought he was so cool when he played a queen
When he made love to a deaf woman
For the world to see.
But we're used to it.
We can only fuck to get access to power
And if we don't we're raped anyway.
All single women with children
with no health care, no child care, no child support–
We're used to it.
It's a life of Lies
It's a life of Selling Out

And the last time I saw my mother she had a skillet
above my head.

Why should I pretend to stop drinking? For the chil-
dren? Shit, they're the reason I drink! My so-called
daughter hasn't called me in years because of my so-
called intoxicated lifestyle, my liquor-motivated deci-
sions. No one cares about me. Why should I care about
me? Let's see how low they'll let me fall before they'll
pick me up. Besides, I can stop whenever I want. And
you know children, as soon as they're in trouble they
call on you to bail them out.
I know everything, that's my problem. I'm too smart for
this world. My analysis can be so deliberate that I'm
known for my psychic pain. Clever, smart, driven pain.
I'm always right.
I feel you shiver when you suspect me drinking, but
you'll never find my vodka behind the kitty litter box!
'Cause I'm the only one who works around here. No
matter how much I drink I always make it to work on
time! I'd like for you to feel pain, to feel my pain of

raising a family alone. I don't get any widow benefits. People and family members are scared of me. They don't know what to do with a widow. Everyone blames his life on me. Everyone blames his death on me, even though he pulled the trigger. And the only consoling words I ever receive are, "You're so lucky he didn't kill you and the children too." Or, "You're so lucky he blew his brains out in the garage and not in the living room." Yeah, I'm lucky. I'm so lucky. I hate people who rationalize suffering. I hate people who have to have a reason for everything. They can't just accept the fact that bad things happen to good people because if they did they'd be like me—out of control. Out of control. Yeah, I admit it. I'm out of control.

I deserve the right to drink. No one else rewards me for going to work everyday, for cleaning this damn house. I had five kids, three miscarriages and one abortion. I've been a mother, a whore and a slave. I've been needed, rejected and desired, but never valued by anyone. Soon my words will slur, my muscles and facial expressions will drop. My head will bob, my sentences will run on and on and on. And I'll tell those god damn repeated stories over and over and over and over again and I'll never stop even though you'll want me to. I'm a living Hell and I intend to keep my devil out.

I live in a state of never getting better
I live in a world of caving in
I live in a life where
pleasure means death
I hate REHAB
I hate DENIAL
I hate Queen Victoria.

Why is it I hate independence?
Independence Day?
I want Dependence Day.
I want to be dependent on drugs, alcohol, and sex
again
I want dependency
This country takes all my independence away
They are trying to take abortion away
and freedom of speech
Because this country spends more time on this stupid
burning flag
When our own citizens' stomachs are burning with
hunger
When people with AIDS are burning with fever
Let me tell you, God has failed
And God is bureaucracy
God is statistics
God is what you make and not what you feel
We've been oppressed
We're only tolerated
And they say we're lucky cause we don't live in China
But they don't even care about the people of China
I want more than a biological opportunity
I want more than a biological opportunity
Listen to me . . .

AUNT MANDY

I grew up to the stories of my Aunt Mandy.
In public it was cancer of the uterus, in private
Aunt Mandy died because she was butchered.
She died from an abortion,
a hatchet job.
She lay dying in the basement.
They found rats eating her insides out,
in fact all of her blood drained out of her.
All of the women bowed their heads
at the story of Aunt Mandy
'Cause they knew it could have been them.
It could have been them.
It was talk amongst women, mothers
mothers
a chance you took to be a mother
to be a woman.
Whatever the reason, the decision
a woman would make the decision knowing

she could die
Because in this world a woman isn't worth much
Sometimes it's a hanger—
sharp, rusty, bleeding
Sometimes it's a knife—
to cut out our soul.
Sometimes it's fire, falling from buildings,
stairs, drowning or suicide.
Like I said, a woman isn't worth much
A woman's life isn't worth much.

And as a child I would sit with the women
whose lives were as mothers
only valued as mothers
grandmothers who remembered when
women couldn't vote
mothers who remembered not having credit
couldn't buy her own car, house or dream
A woman can't be president
But a mother never abandons her children
Children are her life
She'd die for her children
war, famine, plague and drought.
A woman must always be a mother
Children are her life
They never talk about a woman who can't
be a mother, it doesn't matter what else a woman
accomplishes for
A WOMAN MUST ALWAYS BE A MOTHER
A WOMAN MUST ALWAYS BE A MOTHER
A WOMAN MUST ALWAYS BE A MOTHER
'Cause a woman isn't nothing if she isn't a mother
A woman must always be loved but never treated
like her own body is her own.

There is mother earth who creates famine and plenty
calm and storm.

It's my body
It's not Pepsi's body
It's not Nancy Reagan's body
It's not Congress's body
It's not the Supreme Court's body
It's not Cosmopolitan's body
It's not George Bush's ugly-conscience, never-be-
responsible, let-the-world-rot body
It's not Cardinal O'Connor's Catholic church-
homophobic-hate women-hate queers-oppressive-
DEVIL-SATAN-no children body
IT'S NOT YOUR BODY

You know nothing about God—
God is dead
God is death
If he cared about life
He wouldn't kill with AIDS, he wouldn't allow
Chinese students to be executed and die
And be forgotten a year later.
He wouldn't allow Jennifer Levin to die
Yeah, god is death, god is dead
I want my body
But it's never been mine
It's only for creating babies
with a man's name on it
'Cause my name is never good enough
My name is not good enough
'Cause if I use my name its real name is
BASTARD BASTARD BASTARD
I ain't got health insurance

'cause I refuse to take the HIV test
and, baby, I can't afford it.
My body is the government's, let them pay me
My body is paid in full by me.
My body is mine.
It's funny, but in this country if you test positive you
ain't gonna be covered.
It's the sick that need the insurance.
We have no-fault car insurance.
So why not no-fault health insurance?
'Cause we care more about cars than we do people.

One day, I hope to God, Bush
Cardinal O'Connor and the Right-to-Lifers each
returns to life as an unwanted pregnant 13-year-old
girl working at McDonalds at minimum wage.

And she's on the floor of some rat-scum alley
screaming with a rag in her throat
with no anaesthesia
nothing clean
and the doctor is not a real doctor.
Who cares—she's dead
Who cares—she's dead anyway
Who cares—she's already dead
Who cares—she's a goner
Who cares—she's poor trash anyway
To be slaves to our biology
so we aren't successful
so we make the beds and vacuum the carpet
Slaves to biology.

But the abortions will never stop
Aunt Mandy watches us from above
There will always be Aunt Mandys

Who are
BUTCHERED LIKE A PIG
BUTCHERED LIKE A PIG
BUTCHERED LIKE A PIG
and forget God and religion
for all they do is represent fantasties of men
that perpetuate hatred of women and gays
I want a homosexual god
I want a female goddess
I want a lesbian god
I want a Black god
I want a brown goddess
I want a yellow god
I want a red goddess
I want a god in the image of real humans, here, now.
Remember, we have the right to feel
But all I'm hearing is
Are my tits big enough?

ST. VALENTINE'S MASSACRE

I was afraid of being loved—
 so I loved being hated
I was afraid of being wanted—
 so I wanted to be abused
I was afraid of being alone—
 so I alone became afraid
I was afraid of being successful—
 so I successfully became nothing
I was afraid of not being in control—
 so I lost control of my own life
I was afraid that I was worth nothing—
 so I wasted my body to nothing
I was afraid of eating—
 so I eat to my heart's content
 so I drink to my heart's content
 I party to my heart's content
 I fuck to my heart's content
 (always with rubbers)
 I spend to my heart's content
 I eat to my heart's content

and then I puke it all up
 I take laxatives
 and shit and shit and shit and shit
I'm afraid I shit a long time
for I'm nothing but shit
My life is worth nothing but shit.

I've had my share of love letters.
I'm writing to tell you that I love you but I don't ever
want to see you again.
I never want to talk to you again, hear your voice, smell
you, touch you, hold you.
I want you out of my life. I love you but I want you out
of my life! But remember, I will never love anyone as
much as I love you!

I'm beating you with this belt, this whip, this stick
because I love you.
You talked back to me and your mother. Your bloody
back, your scars, are evidence of my love.
I beat you as a child because I loved you.
The only emotion I ever saw from my parents was
anger.

I'm sleeping with your best friend because
I want to make you jealous
and make you realize that you love me.
I make you jealous because I love you.
I sleep with your best friend because I love you.
I am hurting you because I love you.

I ignore you because I don't want you to know that I
love you till you show me that you love me. I ignore you
because I love you.

I tied your hands together as a child because you were touching your penis too much. I tied up your penis because I love you.

I put you down as a child because I didn't want you to expect too much out of life. I ridiculed you, I belittled you because I loved you.

I abused my children sexually because I didn't want someone else who didn't love them to do it. I don't hate them, I love them. I show them love.

I shot myself because I love you.
If I loved myself I'd be shooting you.

I drink myself to death because I never loved myself.
I love you. But I love my liquor more.

Yes, I know love. That is the reason I hate the people I love.
My whole life is untangling what was hate and what was love.
My whole life is falling in love with those who hate me while loving me.
I always fall in love with the cruel, the sadistic
For it's better to feel abuse than to feel nothing at all.
It's better to feel abuse than to feel nothing at all.

In commemoration of St. Valentine's Day Massacre that killed violently sixty years ago today
America commemorates this event by killing thousands of its citizens.

The first plan of death will be called
THE YEAR OF THE CHILD
—all policeman will use infants and toddlers as bullet-
proof vests
—all six-year-old children will be issued guns upon
entering school
—all ten-year-old children will be required to sell crack
to sponsor after school programs because of limited
government funding.
We are happy to report the plan is working.
Other forms of death are the following:
freezing, starvation, homelessness, AIDS, lead poison-
ing, poor healthcare, no drug rehab programs, no free
needles, AIDS, no prenatal care, child abuse, rat bites,
polluted lakes rivers seas oceans and air, toxic waste,
AIDS.

Grab your dick
grab your maleness.
Girls, grab it.
Girls, grab your energy
fucking pussy
tie bandages to your pussies.
I like to cut off the ears of males, he said.
I like to cut off naughty male bits
string foreskin as necklaces.
Sure, I've eaten a doggie out
'Cause I'm a man. Nothing better.
I'll eat dog pussy 'cause I'm a pet lover.
I'll eat chicken hearts
bite snake heads.
I'm a military kind of guy.
I saw a guy shoot himself
happened to be my dad.

I saw a man go berserk
happened to be myself.
I saw a child cut herself with razor blades
never knew her name.
I saw a guy beat up his wife
just for the hell of it.

'Cause I'm a man—a man doesn't have friends like a
woman does.
We don't tell our feelings like women do.
We don't show our feelings like women do.
The only feelings we show are no no feelings at all.
Ain't got a friend, but I got a drinking partner.
Ain't got a confidante but I got a hunting buddy.
Ain't got a shoulder to cry on, but I got a shoulder to
carry my gun.

Everything smelled like an adult diaper
Everything smelled like an adult diaper
The whole world was rotting away.
Everyone's soul was rotting
Everyone's heart was decaying
Everyone's spirit was dead.
But the old people knew what was going on.
They say, hate's got a bad smell. You can tell whenever
it enters a room.
But there were some people who weren't smelling bad
Like good hearted ones
Like people with good feelings
Like people with soul
Hate got a stink about it
Hate got its own type of odor
Old people know.
You might be rich, baby, got everything you want

but you got a stink, baby, you got your kind of odor
Greed's got its own kind of smell
Hate's got its own kind of smell.

WE ARE THE OVEN

Hitler likes to have Eva Braun shit on him. That's what
Eva likes, too. Adolph wants Eva to take a big, brown,
hot steamy shit on him. Shit in my mouth. I want a
blonde Arian shit in the Führer's mouth now.
The Führer has a fear of pubic hair. It looks like sperm.
I don't like pubes, that's why I like to fuck big, hairy
ears.
Don't be alarmed, I have a small penis and Eva has
very large ears and the Führer never comes.
The Führer's first dream was of attacking his mother's
womb and destroying his brothers and sisters. He
blamed his disturbing dreams on being delivered by
ice tongs.

At eight she was molested by her brother
At ten she was fingered by her daddy
At twelve she was beaten by her mother

At fourteen her white baby was kidnapped by the Nazis.

It isn't your penis that gives me pleasure, it's my clitoris, she'd say as she masturbated and sucked her arm and pretended she was sucking her own breast.

You said that you don't lift your son for the potty at night. When he wets the bed, what do you do?
I BEAT THE SHIT OUT OF HIM!
When your son cries?
I BEAT THE SHIT OUT OF HIM!

Berlin, 1938: The campaign toward the elimination of Jews and the handicapped intensified.
November 10, 1938: Night Of Broken Glass—Jewish shops were demolished, synagogues set on fire.
Germany, 1938: Jews were not allowed to own property, have businesses and live in certain areas. Civil rights were taken away. This was the beginning, a movement toward setting up death camps, ovens for the Jewish people.

America, Now: Many people think that junkies and people with AIDS deserve to die. Women who are dependent on the state should be sterilized because they are unproductive citizens, say the zealots.
In principle we are not very different.
We keep our victims ready.
What is our form of 1938 Nazism? Who are our zealots with evil ways?
Our Christian holymen preach as if all homosexuals will burn in hell.
Our politicians allow the homeless to rot on the pavement.

Many believe HIV carriers should be branded like those
in concentration camps.
Many believe that by giving IV drug users clean needles
we are giving them the wrong message.
WE KILL BY NOT DOING ANYTHING
AND ALLOW DEATH FOR NO APPARENT REASON.
We have our own SS—the 700 Club.
We have our own Himmler, our own Goebbels—
William Buckley, Patrick Buchanan.
Evans and Novak—our conservative columnists who
maliciously condemn artists for expressing themselves.
Our religious fanatics who try to destroy and distort
the artist, the gay, the lesbian voice—Wildmón,
Robertson and Helms.

Now they can't kill the commie
So they are out to kill the soul of America—me and
you.

IT'S JUST THAT OUR OVENS ARE AT A SLOWER SPEED.
IT'S JUST THAT OUR OVENS ARE AT A SLOWER SPEED.

We keep our victims ready.
These religious fanatics want only a voice that is their
voice
Not a voice of diversity, a voice of difference, a voice for
choice
A voice of strength for togetherness.

You see the wall is beginning to crumble for white male
power.
They will have to share the power, share the planet,
and they don't want to.
If they could still have slavery they would.

But I cry at night knowing that someone is dying.
Remember: you can still die because of the color of
your skin.

We have our fascist state, our Auschwitz, our racist
attacks—
Howard Beach, Bensonhurst, Tawana Brawley, and
never forget Michael Stewart, although they want us to.

We keep our victims ready.
We don't have time for statistics
We don't have time for studies
We don't have time for presidential inquiries.
People are homeless, hungry.
Bodies are walked over in Grand Central Station.
Trump would rather build the world's largest building
than provide the world's largest low income housing
project.

Some folks who call themselves Christians
Would like to put all homosexuals and people with
AIDS in concentration camps.
It's not surprising since America had concentration
camps for Japanese Americans, where people went
insane or died.

We keep our victims ready.
We whites condemn other races for not being like us.
Thank god they are not like us.

And in the coming years, after 1938 in Germany
Music would be made of
murdered childrens' bones.
Exhaled breath burnt with martyrs' cries.

Lampshades, from human skins.
IT ONLY TOOK A ZEALOT AND A FOLLOWER

I'll never forgive Adolph Hitler and the Nazis.
There are some things that I'll never forgive—
 I'll never forgive Robert Chambers for committing
 murder
 I'll never forgive Cardinal O'Connor
 I'll never forgive the whites in power in South Africa
 I'll never forgive our constitution for including slavery
 I'll never forgive our constitution for including slavery
 I'll never forgive our constitution for including slavery
 I'll never forgive us for stealing this land from
 the Indians
 There are just some things I won't forgive.

We are the oven
Our homeless, the victims
and our narrowed American minds
wish to exterminate people with AIDS
instead of exterminating the disease
Wish to exterminate the poor, the suffering, the depen-
dent
We'll happily pay for their deaths but never their lives
No, we aren't decadent
We are violent, cruel and deliberately unjust.

What's at the end of this night?
Oh, I try and come here to have a good time.
'Cause outside it's only a bad time.
What's at the end of this long night?
Where people can enjoy their sexualities.
Where the sick and suffering are comforted.
What's at the end of this long long night?

Where the homeless are housed.
Where humanity is more valuable than money.
Where the soul, the heart and mind meet.
Where every empty hand is held.

WHY CAN'T THIS VEAL CALF WALK?

You sold my soul before I could speak.

Raped by an uncle at eight
Known addiction all my life
Let me dance for you
My daddy was a preacher
preached the bible
 beat my mama
 I sell my babies
 I sell my bodies.

To keep 'em from stealing the women had to strip and
had to work naked.
It looks bad, but to me it looks normal.

Why can't this veal calf walk?
'Cause she's kept in a wooden box which she can't turn
around in. She's fed some antibiotic-laced formula,

and she sleeps in her own diarrhea,
chained in a darkened building, immobilized and sick
and then we kill her and eat her.

Him hurting me is not my fault.
Your hurting me is not my fault.

After I was raped by my doctor
I didn't want to be close to anyone.
I cut off my hair
I cut off my breasts
I cut off my hips
I cut off my buttocks
 nothing revealing, nothing tight
 neutered.
You say I got what I deserved
I let the doctor examine my crotch
My legs were in the stirrups pinned down
And you gave me a shot
I couldn't see you but I could feel you. I couldn't do
nothing.
Everyone always told me I couldn't do nothing my
whole life
Just seeing the veal calf now.

Everyone says I deserved it—
I'm a hussy, I'm a tramp
I'm a whore
'Cause I wear lipstick?
work at night?
and drink bourbon straight?
I'm a preacher girl
Daddy, teach me right.

When I said NO
you didn't listen to me.
When I said NO
You fucked me anyway
When I said NO
I meant no
When I said NO
I wasn't playing hard to get
And I never meant yes
You raped me
I took a shower, a hot one
but I couldn't get clean
 his sweat his semen
 his skin smells near
Another bath another shower
my whole body was covered with hickeys
I just cried, I just cried.
When I reported it
Policeman said, "Hey, slut, you led him on."
The doctor cleaned me up, stuffed me with gauze
I bled three days with the morning-after pill.
And when they returned my empty wallet
Mr. Policeman said, "If you don't suck me I'll blow your
brains out."

GET ME USED TO IT! GET ME USED TO IT!
But I can't. I want something better for my sisters my
daughters. And everyday I hear them laughing at me
from street corners. Sizing me up. They don't say it,
though, when I walk down the street with a man 'cause
then I'm his property.
And the menfolk say as I pass—
 I prefer small women
 I like to dominate women

I enjoy the conquest of sex
Some women are asking for it
I get excited when a woman struggles
I'd like to make it with her
I hope I score tonight.

And when the last man said his violence
I knew I couldn't do anything to them
so I'd do something to me.
I went and took a knife and I cut out my hole
but it just became a bigger hole
and all the men just laughed and said
She's too big to fuck now
And I felt relief, but then they said,
We can all fuck her at the same time.
But I was bleeding so they left me alone
Men don't touch women when they bleed
It's unclean, unless they cause the bleeding.

And then I hoped I would die but of course I didn't
I heard a sound, a whimper
and I realized I was in the same room as the veal calf
And veal calf walked over to me
Veal calf limps. Veal calf stinks.
And I look into veal calf's eyes
and I know veal calf's story
And I said I was sorry for her
And she said I got to keep trying
And she asked why I was there, too
And I spoke my story:

When the big man like a big daddy like a big uncle, big
uncle whom I loved, when the cop, the teacher, the
country doctor, the date, the neighbor, the authority

man whom I trusted and respected visited me in my
own bed, broke into my own house, lived with me, on
my own street in my own car, looked at me, grabbed
me, mangled and hurt me, slapped me and pushed me,
touched my privacy, destroyed my feminine instinct,
entered and took and hurt and screams and bruises,
new colors on my skin . . .
Whenever I see a rainbow in the sky I only see an angel
being raped.

When I said NO I meant No
But you did it anyway
When you were gone your body, your stink remained
Tried to wash you wash you off me, my body, my skin
in me in me in me
Wash it off me, still not gone, scrub it off, burn you off
me
Try to kill me, I don't like me, 'cause I smell like you.

I'm hurt, abused. I slice me.
I burn me. I hit me. I want this body to die. I want to be
old and undesired.
I want my body back
I want my personhood back—
 society, culture and history
 media, entertainment and art
I'm more than a hole
But you hate us because we can have babies and you
can't.
I'm more than a hole
But you envy us because we can have children who
love us unconditionally.
I'm more than a set of tits
But if I don't have the right size for you

I'm never enough for you
So, we make implants and surgery just for you.
We create a woman that never existed.
It's survival of the female species.
And I'm more than a pair of legs
But if they don't do more than walk
I'm a dog.
If I nurse my babies and my tits sag
And I'm told you won't desire me
You can't be a mother and a whore
No one loves a smart woman
I'm more than a piece of ass, a good fuck and lay
For the woman—our society only relates and values
you for your desirability.
The Woman Is Private Property.

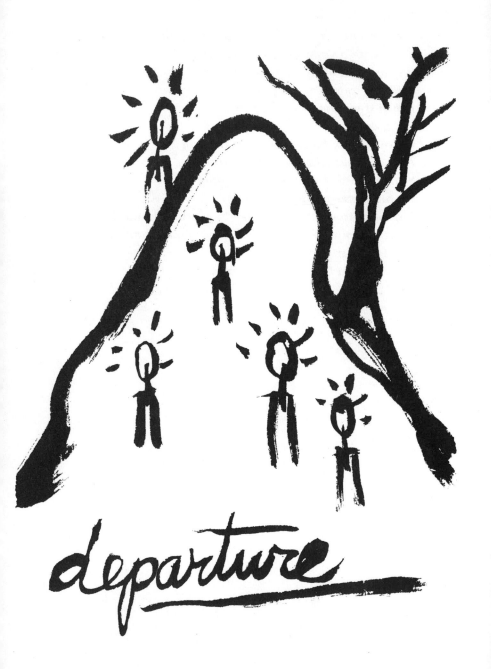

departure

DEPARTURE

Tell me what to say when I visit
And my sick friend says
 When am I going to get better?
And all I can say is
 If we could make you better we would.

And your lover says
 I want you to find someone after I die
And you say
 Don't talk like that
 Let's not think about it
 I'll never forget you.
Just hold your lover's hand
And keep holding it
But it's too weak
And that hand is inside you now.

Your friend says
 I'm going to die but I'm not ready to die.
And you say
 Well, even though you're young you've led a full life.
Or, there is a time for everything
Or, it's not easy for you now
Or, just hold your friend's hand
 look into your lover's eyes
 and think to yourself
GOD IS DEATH
And the friend tries to make you feel better and says
 I'm going to get better, aren't I?
 I'm going to walk right out of here.
 I can feel it.
 And you hold your friend's hand
 harder HARDER
And in time your friend says
 I see the light
 · I'm going to die now
 I'm going to die now.

And after they've died, there's something in me that
dies. Something is always lost.
I have something more in common with
the other side than with this side.
And I think about ending it all
but I don't because someone else needs me.
And I do different things, different rituals—
the friend who is left behind, the widower, the widow,
the lover who is left behind.
For some, the passing to the other side means
we burn, we burn, we burn their clothes
'cause we are cold inside without you.
Sometimes we destroy their memories because our

lives now mean nothing.
We give everything away that was theirs.
'cause we have been giving and giving and giving
and we want to continue
that lost continuation, that thread, that same feeling.
That feeling that if we become as good, as good,
as good
maybe we could make you better
and maybe if we keep on giving
we'll get you back one day.

When you were holding the departed
you were whispering in their breath
You smelled that last breath
You tasted that last breath
You feel you failed, and you became mother, father
You became the only connection
with the outside world.
When you were holding the body—
we know we still have to bid the soul farewell.
And sometimes the spirit stays for days—
scared and tired from bodies that wouldn't give up.
Lives that had to make it, be the best.
Some souls deny death while the living deny life.

At first you're gentle—
Release, child, release into clear blue, into the soft
world of fragrances, of musk.
Become the first words of a child, become the first
feelings of love.
Become the reasons for me to go on living,
or I'll go on dying.
And you know it's not over
for you still must scatter ashes

at some place which, as you pass by in the future, will
make you relive the loss all over again.
You laugh, too.
He planned it that way.
Sometimes you place them in coffins with gifts and
charms and talismans.
Beds of silk and brocades, and smells of oriental
jasmine.
But once the coffin door is closed
you don't sleep with doors closed ever again.
Your sides where his arms held you
like two spoons as you slept now ache.
When you hear sand and earth shoveled
you relive the saddest time again
and then you are empty.
And so you run home and open his closet
and wrap your arms around his clothes,
you take all the sleeves
and wrap them around your neck,
and you breathe your lover's smell
and you cry and cry.
All the lights flicker in the house,
butterflies follow you and sit on your shoulder,
birds fly into windowpanes,
mirrors shatter and you realize
you've lost your most prized possession.
Not a ring, a token of his love
but him.
His initials appear on license plates
on cars in front of you.
He was always so good at leaving messages.

THE BLACK SHEEP

After a funeral someone said to me
You know I only see you at funerals
it's been three since June—
been five since June for me.
He said I've made a vow—
I only go to death parties if I know someone
before they were sick.
Why?
'cause—'cause—'cause I feel I feel so
sad 'cause I never knew their lives
and now I only know their deaths
And because we are members of the
Black Sheep family.

We are sheep with no shepherd
We are sheep with no straight and narrow
We are sheep with no meadow

There is
always
one
black
sheep
in
every
family

We are sheep who take the dangerous pathway through
the mountain range
to get to the other side of our soul.
We are the black sheep of the family
called Black Sheep folk.
We always speak our mind
 appreciate differences in culture
 believe in sexual preferences
 believe in no racism
 no sexism
 no religionism
and we'll fight for what we believe
but usually we're pagans.
There's always one in every family.
Even when we're surrounded by bodies
we're always alone.
You're born alone
and you die alone—
written by a black sheep.
You can't take it with you—
written by a former black sheep.

Black Sheep folk look different from their families—
It's the way we look at the world.
We're a quirk of nature—
We're a quirk of fate.
Usually our family, our city,
our country never understands us—
We knew this from when we were very young
that we weren't meant to be understood.
That's right, that's our job.
Usually we're not appreciated until the next generation.
That's our life, that's our story.
Usually we're outcasts, outsiders in our own family.

Don't worry—get used to it.
My sister says—I don't understand you!
But I have many sisters with me tonight.
My brother says—I don't want you!
But I have many brothers with me here tonight!
My mother says—I don't know how to love
someone like you!
You're so different from the rest!
But I have many mamas with me here tonight!
My father says—I don't know how to hold you!
But I have many many daddies with me here tonight!

We're related to people we love who can't say
 I love you Black Sheep daughter
 I love you Black Sheep son
 I love you outcast, I love you outsider.
But tonight we love each other
That's why we're here—
to be around others like ourselves—
So it doesn't hurt quite so much.
In our world, our temple of difference
I am at my loneliest when I have something to celebrate
and try to share it with those I love
but who don't love me back.
There's always silence at the end of the phone.
There's always silence at the end of the phone.

Sister—congratulate me!
NO I CAN'T YOU'RE TOO LOUD.
Grandma—love me!
NO I DON'T KNOW HOW TO LOVE
SOMEONE LIKE YOU.
Sometimes the Black Sheep is a soothsayer,
a psychic, a magician of sorts.

Black Sheep see the invisible—
We know each other's thoughts—
We feel fear and hatred.

Sometimes some sheep are chosen to be sick
 to finally have average, flat, boring people say
 I love you.
Sometimes Black Sheep are chosen to be sick
 so families can finally come together and say
 I love you.
Sometimes some Black Sheep are chosen to die
 so loved ones and families can finally say—
 Your life was worth living
 Your life meant something to me!
Black Sheeps' destinies are not necessarily in having
families, having prescibed existences—
 like the American Dream.
Black Sheeps' destinies are to give meaning in life
 to be angels
 to be conscience
 to be nightmares
 to be actors in dreams.

Black Sheep can be family to strangers
We can love each other like MOTHER
FATHER SISTER BROTHER CHILD
We understand universal love
We understand unconditional love
We feel a unique responsibility, a human responsibility
for feelings for others.
We can be all things to all people
We are there at 3:30 AM when you call
We are here tonight 'cause I just can't go to sleep.

I have nowhere to go.
I'm a creature of the night—
I travel in your dreams—
I feel your nightmares—

We are your holding hand
We are your pillow, your receiver
your cuddly toy.
I feel your pain.
I wish I could relieve you of your suffering.
I wish I could relieve you of your pain.
I wish I could relieve you of your destiny.
I wish I could relieve you of your fate.
I wish I could relieve you of your illness.
I wish I could relieve you of your life.
I wish I could relieve you of your death.
But it's always
Silence at the end of the phone.
Silence at the end of the phone.
Silence at the end of the phone.

The End

ABOUT THE AUTHOR

Karen Finley is a New York–based artist whose performances have long provoked controversy and debate. Her artworks are in numerous collections and museums including the Pompidou in Paris and the Museum of Contemporary Art, Los Angeles. She has appeared in many independent films, including Jonathan Demme's 1993 Oscar-winning film *Philadelphia*. Her many books include *Enough is Enough, A Different Kind Of Intimacy, George and Martha*, and *The Reality Shows*. She is a professor at Tisch School of the Arts at New York University in the department of Art and Public Policy.